POSTCARD HISTORY SERIES

Pasadena

IN VINTAGE POSTCARDS

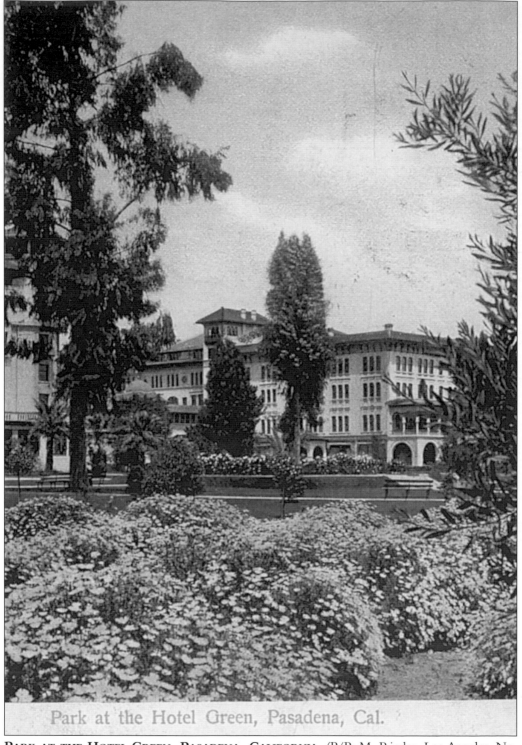

Park at the Hotel Green, Pasadena, Cal.

PARK AT THE HOTEL GREEN, PASADENA, CALIFORNIA. (P/P: M. Rieder, Los Angeles. No. 3764. Made in Germany. Postmark: February 1905.)

POSTCARD HISTORY SERIES

Pasadena

IN VINTAGE POSTCARDS

Marlin L. Heckman

ARCADIA

First Printed 2001.
Reprinted 2003, 2004.

Published by Arcadia Publishing,
an imprint of Tempus Publishing, Inc.
Charleston SC, Chicago, Portsmouth NH,
San Francisco

Printed in Great Britain.

Library of Congress Catalog Card Number: 00-111086

For all general information contact Arcadia Publishing at:
Telephone 843-853-2070
Fax 843-853-0044
E-Mail sales@arcadiapublishing.com
For customer service and orders:
Toll-Free 1-888-313-2665

Visit us on the internet at http://www.arcadiapublishing.com

CONTENTS

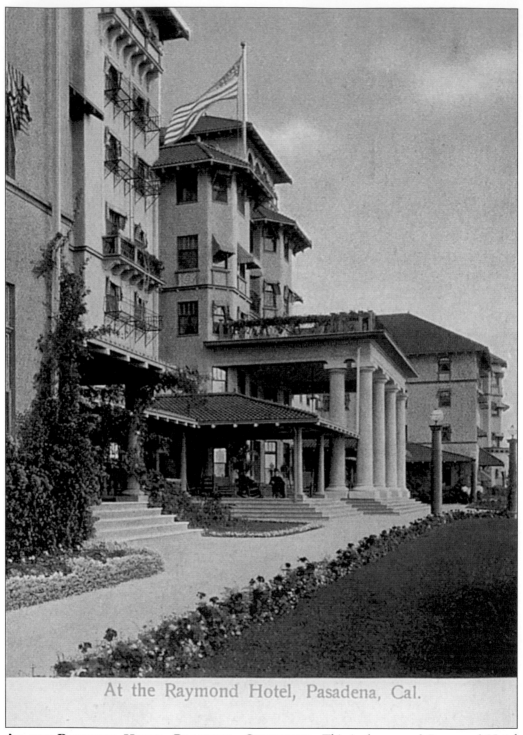

At the Raymond Hotel, Pasadena, Cal.

AT THE RAYMOND HOTEL, PASADENA, CALIFORNIA. This is the second Raymond Hotel constructed on this site. The original wooden structure opened in 1886, and was destroyed by fire in 1895. (P/P: M. Rieder, Los Angeles & Leipzig, No. 3327.)

INTRODUCTION

The City of Pasadena, California, lies approximately 9 miles north of Los Angeles, against the Sierra Madre mountain range. Los Angeles postcard publisher M. Rieder noted on an early Pasadena postcard, "Pasadena, the favorite of tourists and sojourners from the East, is a city of homes. There are many handsome churches and the educational advantages are exceptional. The hotels are the best in the country." Another description of Pasadena in the late nineteenth century read as follows: "Twenty-five miles from Tidewater. Slopes southwest toward the sea, sixty-five feet to the mile. Elevation, nine hundred feet above sea level. Number of orange trees planted from three to fifteen years old, 180,000." (Manuel Pineda, Pasadena Area History, Pasadena: Historical Publishing Co., 1972, p. 127.)

Incorporated in 1885 as the City of Pasadena, the town had previously been known as the Indiana Colony, reflecting the large settlement of Hoosiers in the area. The name, Pasadena, comes from the Chippewa language, meaning "the valley between the hills," or "crown of the valley."

With numerous resort hotels, Pasadena was originally known as a special place to visit, with its natural beauty and nearby mountains. The Raymond Hotel, noted as a "tourist" hotel, opened in 1886 with 1,500 people attending its opening. The original wooden hotel burned to the ground in 1895, and was replaced by a stucco structure. Resort hotels were popular "winter residences" for many people in the late nineteenth and early twentieth centuries. Carpenter suggests, "As was popularly remarked, 'A guest having spent one or two seasons here, has a fifty percent probability of staying.'" (Thomas Carpenter, Pasadena Resort Hotels and Paradise. Azusa, CA: Marc Sheldon Publishing, 1984, p. 2.) Many who came to visit later came to live.

In 1890, the Valley Hunt Club had a parade of carriages covered with flowers, which Dr. Charles Holder named the Battle of the Flowers. In 1891, it was called the "Dead of Winter" festival. The continuing tradition of a parade of floral floats on New Year's Day is shared with the world via television as thousands line the streets of Pasadena for the annual Tournament of Roses parade. The former Wrigley mansion on Orange Grove is now the home of the Tournament of Roses Association. In early years, bull fighting was a special activity on New Year's Day. Since 1902, an annual football game, now played in the Rose Bowl, has been a feature of the New Year's Day celebration in Pasadena.

Also in the 1890s, Professor Thaddeus Lowe achieved a dream of a way to share the nearby mountains with tourists by constructing what became known as the Mt. Lowe Railway. It was advertised as "the grandest of all Mountain Railway Rides—Magnificent Panorama of Earth, Ocean and Islands." It opened to the public on July 5, 1893. "Passengers arrived at the base of Echo Mountain in Altadena by the electric train 'red cars' from Pasadena. Then they boarded the Great Cable Incline cars and rode up a 60% grade to Echo Mountain House and Chalet. For those who wanted to continue on they could ride to Crystal Springs, the site of the Alpine

Tavern, located at the 5,000 foot level." (Michaelson & Dressler, *Pasadena a Hundred Years*, Pasadena: New Sage Press, 1985, p. 141.) The cars to Mt. Lowe ran for another 40 years after Lowe lost the Mt. Lowe Railway in 1896 due to financial losses.

The Tournament of Roses and Carnival Edition of the *Pasadena Daily News* for January 3, 1911, carried a page of citizen statements. Clara B. Burdette (Mrs. Robert J.) wrote the following in "Why I Live in Pasadena": "Because the climate of Southern California is better than that of Southern Italy—the plains are more beautiful and the sunsets as fine as those in Egypt—the wildflowers as gorgeous as those of Palestine—and the skies bluer than those of Greece is reason enough—and because Pasadena is the best city in California I hope to live and die here." Adolphus Busch wrote: "I selected Pasadena as the winter home of my family because I consider it a veritable paradise, it has no equal in the world, regarding healthful climate, scenery, vegetation, flowers, shrubbery, fruit and general comfort of living. The roads are superb for automobiling, and the pleasure for all outside sports, golfing, tennis, etc., is unsurpassed. Pasadena is undoubtedly destined to become in course of time a most popular American Winter residence." The Burdettes and the Busches were two of many families whose residences on Orange Grove Boulevard were referred to as part of "millionaires row."

Pasadena, the city of resort hotels, mansions, and churches, changed over the years—along with the rest of Southern California. Most cities were affected by the Depression of the 1930s. "Gone are most of the great homes of 'millionaires row,' the citrus orchards with the springtime bouquet of perfume, the town where all men were neighbors, the fields of the wild California Poppy." (Carpenter, *Pasadena Resort Hotels and Paradise*. Azusa, CA: Marc Sheldon Publishing, 1984, p. 171.) Along with newer sights such as the Norton Simon Museum of Art and the Ambassador Auditorium are the continually changing Cal Tech campus and the ever-beautiful Huntington Library and Gardens in San Marino. Developments in "Old Town Pasadena" have brought new life to a part of downtown that was once occupied by empty buildings and boarded-up windows.

Each New Year's Day, the world looks in on Pasadena's Tournament of Roses Parade and football game and its beautiful setting against the mountains, its greenery, flowers, and blue skies and wonders what it must be like to live in the "valley between the hills."

One
PASADENA HOTELS

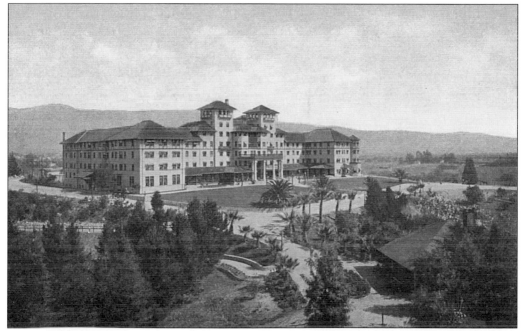

HOTEL RAYMOND, PASADENA, CALIFORNIA. The "new" stucco building had its grand opening December 19, 1901. (P/P: M. Rieder, Los Angeles. No. 3041. Made in Germany.)

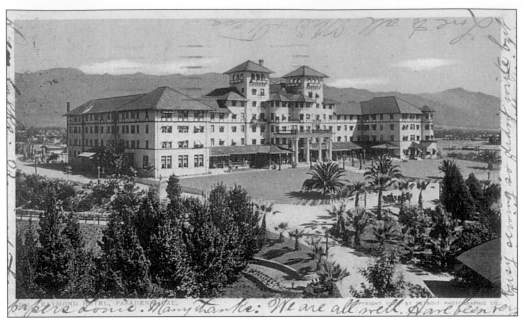

RAYMOND HOTEL, PASADENA, CALIFORNIA. (P/P: Detroit Photographic Co. No. 6192. Copyright 1902. Undivided back. Postmark: March 1906.)

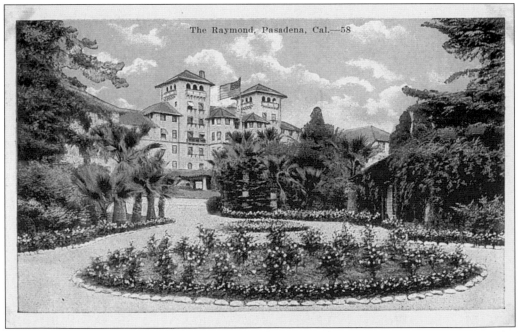

THE RAYMOND, PASADENA, CALIFORNIA. The Raymond Hotel was closed during the Depression, and the building was razed in 1934. (P/P: Unknown. No. 58.)

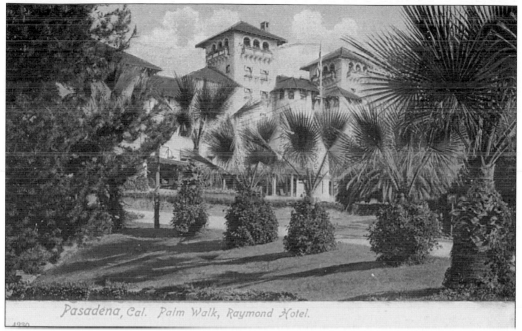

PASADENA, CALIFORNIA, PALM WALK, RAYMOND HOTEL. (P/P: Paul C. Koeber Co., New York & Kirchheim [Germany]. No. 4230. Postmark: April 1909.)

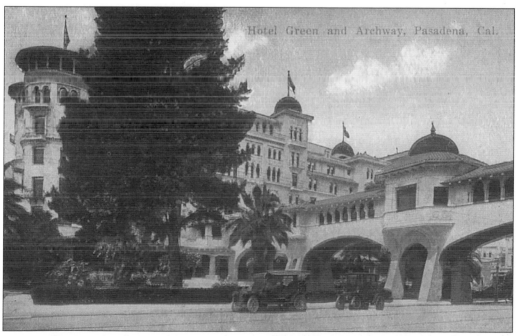

HOTEL GREEN AND ARCHWAY, PASADENA, CALIFORNIA. U.S. President Benjamin Harrison visited Pasadena in 1891, and was a guest at the Green. (P/P: M. Kashower, Los Angeles, No. 35.)

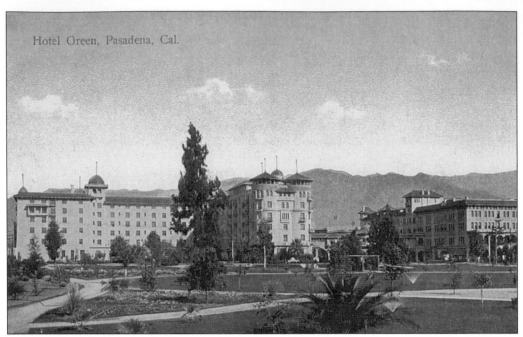

HOTEL GREEN, PASADENA, CALIFORNIA. This was the center of town, with shopping and transportation at its doorstep. (P/P: M. Rieder, Los Angeles. No. 314. Made in Germany.)

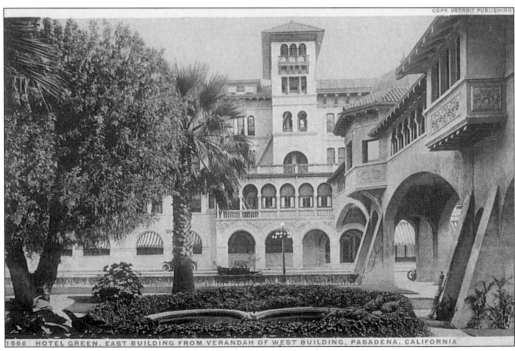

HOTEL GREEN, EAST BUILDING FROM VERANDA OF WEST BUILDING, PASADENA, CALIFORNIA. (P/P: Detroit Publishing Co., No. 71566.)

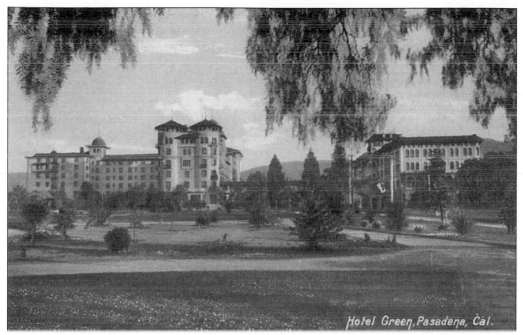

HOTEL GREEN, PASADENA, CALIFORNIA. (P/P: Newman Post Card Co., Los Angeles, No. B90. Made in Germany.)

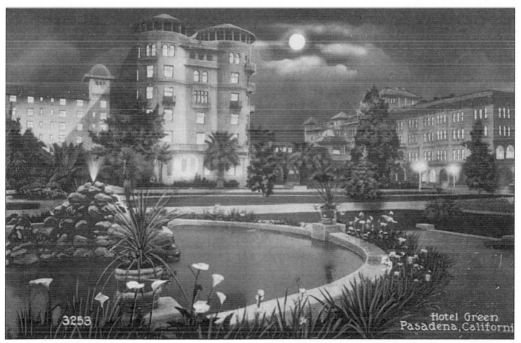

HOTEL GREEN, PASADENA, CALIFORNIA, BY MOONLIGHT. (P/P: Edward H. Mitchell, San Francisco, No. 3253.)

JANUARY SCENE AT THE HOTEL GREEN, PASADENA, CALIFORNIA. (P/P: M. Rieder. Los Angeles. No. 4542. Made in Germany.)

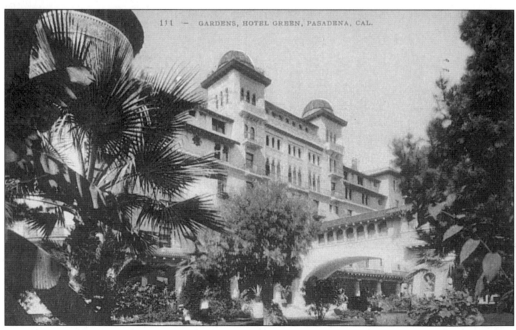

GARDENS, HOTEL GREEN, PASADENA, CALIFORNIA. (P/P: Edward H. Mitchell, San Francisco, No. 111. Postmark: February 1908.)

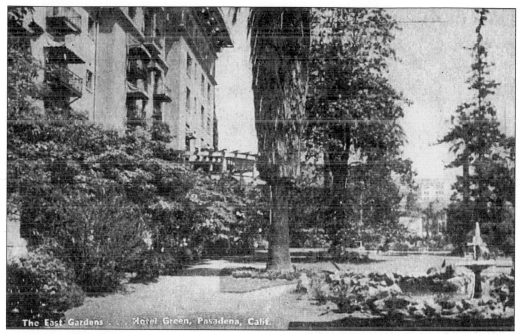

THE EAST GARDENS, HOTEL GREEN, PASADENA, CALIFORNIA. (P/P: Elwood Ingledere, Hollywood, CA.)

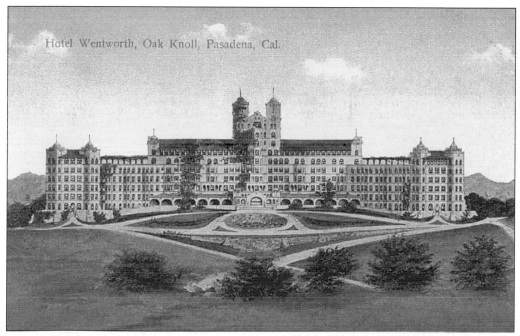

HOTEL WENTWORTH, OAK KNOLL, PASADENA, CALIFORNIA. Forced to close within a few months of opening in February 1907, this hotel stood empty until 1911. (P/P: M. Rieder, Los Angeles. No. 4514. Made in Germany.)

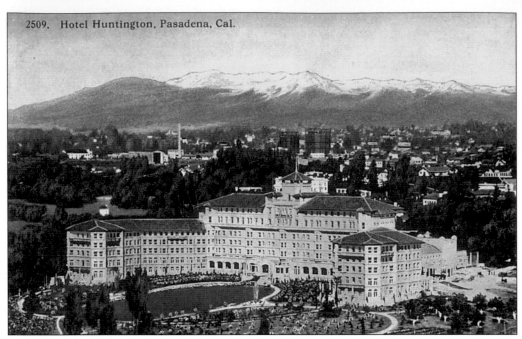

2509. Hotel Huntington, Pasadena, Cal.

HUNTINGTON HOTEL, PASADENA, CALIFORNIA. The Huntington was opened in 1914 by Henry E. Huntington, who had purchased and finished the defunct Wentworth Hotel. (P/P: Western Publishing & Novelty Co., Los Angeles. No. 2509. Postmark: January 1919.)

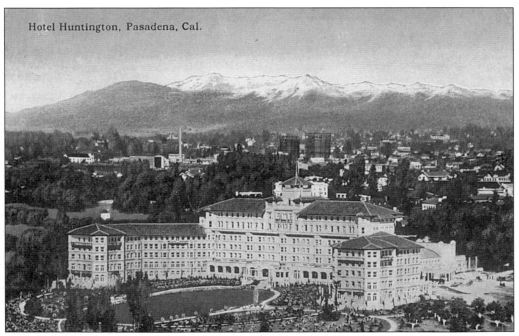

Hotel Huntington, Pasadena, Cal.

HUNTINGTON HOTEL, PASADENA, CALIFORNIA. On the edge of town, the Huntington was a resort for auto and sports enthusiasts. (P/P: Western Publishing & Novelty Co., Los Angeles. No. P3.)

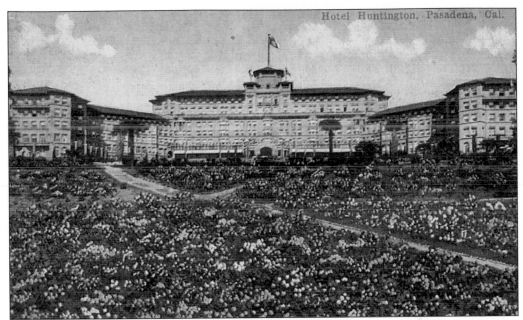

HUNTINGTON HOTEL, PASADENA, CALIFORNIA. (P/P: Van Ornum Colorprint Co., No. 475.)

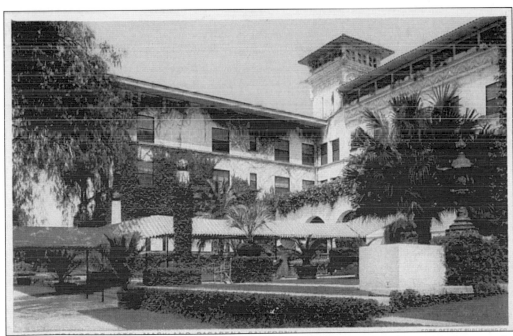

ENTRANCE TO HOTEL MARYLAND, PASADENA, CALIFORNIA. Opened in 1903, this was the first large hotel to serve the year around. (P/P: Detroit Publishing Co., 13560.)

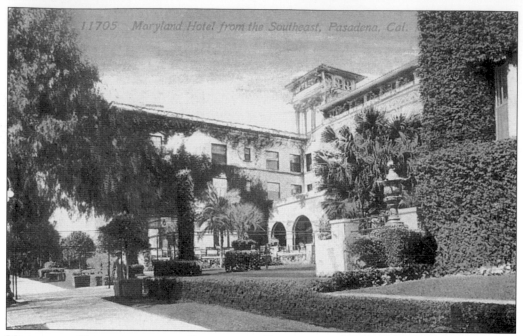

MARYLAND HOTEL FROM THE SOUTHEAST, PASADENA, CALIFORNIA. The Maryland was a unique home-hotel combination. (P/P: Acmegraph Co., Chicago. No. 11705. Postmark: May 1910.)

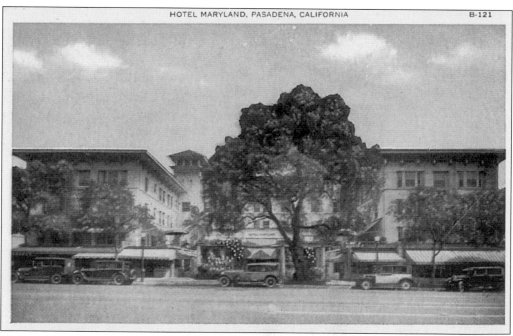

HOTEL MARYLAND, PASADENA, CALIFORNIA. The original hotel suffered a fire in 1914, and the "new" Maryland opened Thanksgiving Day 1914. (P/P: Pacific Novelty Co., San Francisco & Los Angeles. No. B121.)

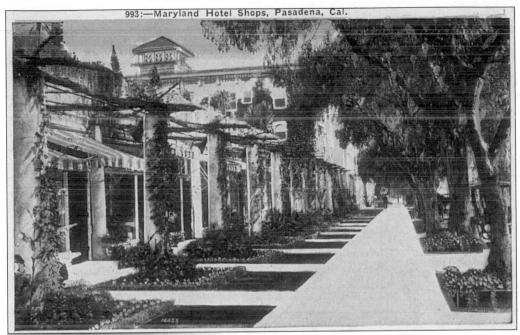

993:—Maryland Hotel Shops, Pasadena, Cal.

HOTEL MARYLAND SHOPS, PASADENA, CALIFORNIA. (P/P: M. Kashower, Los Angeles. No. 993.)

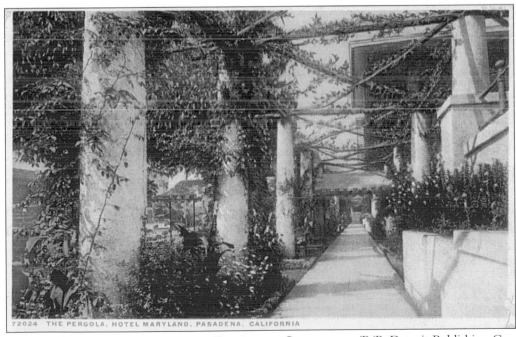

THE PERGOLA, HOTEL MARYLAND, PASADENA, CALIFORNIA. (P/P: Detroit Publishing Co., No. 72024. Postmark: January 1918.)

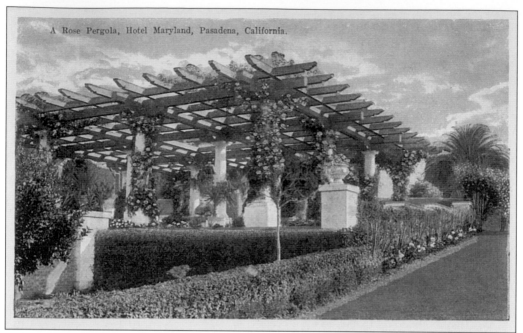

A Rose Pergola, Hotel Maryland, Pasadena, California.

A ROSE PERGOLA, HOTEL MARYLAND, PASADENA, CALIFORNIA. The Rose Pergola was a symbol of the Hotel Maryland. (P/P: California Postcard Co., Los Angeles. No. 24715.)

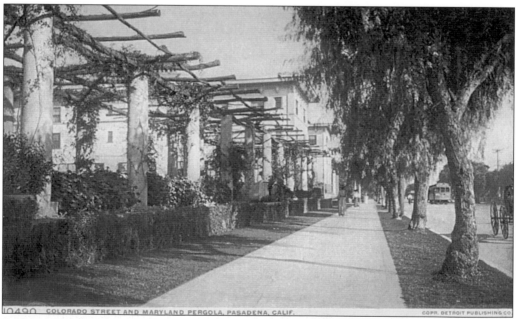

10490 COLORADO STREET AND MARYLAND PERGOLA, PASADENA, CALIF. COPR. DETROIT PUBLISHING CO

COLORADO STREET AND MARYLAND PERGOLA, PASADENA, CALIFORNIA. Text on the card reads: "Just outside the limits of Los Angeles is Pasadena, a thriving city of about 30,000 inhabitants. It is a city of beautiful homes and flowers. Every fruit and flower and ornamental tree and shrub known to Southern California is growing here in profusion. Then there is the Ostrich Farm, known all over the country, and the famous Mt. Lowe with its inclined railway, and last, its magnificent hotels." (P/P: Detroit Publishing Co., No. 10490.)

20

Two

HOMES AND GARDENS

A BUNGALOW COURT, PASADENA, CALIFORNIA. (P/P: Detroit Publishing Co., No. 72145. Postmark: July 1921.)

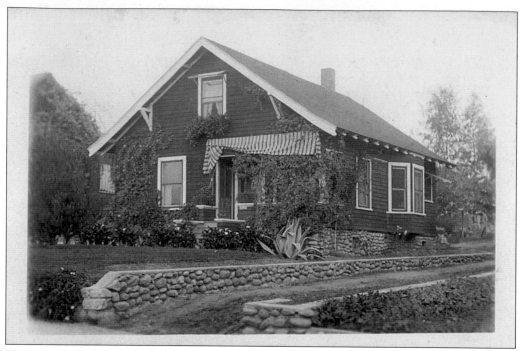

HONNOLD'S RESIDENCE, 1430 IOWA AVENUE, PASADENA, CALIFORNIA. (P/P: Unknown.)

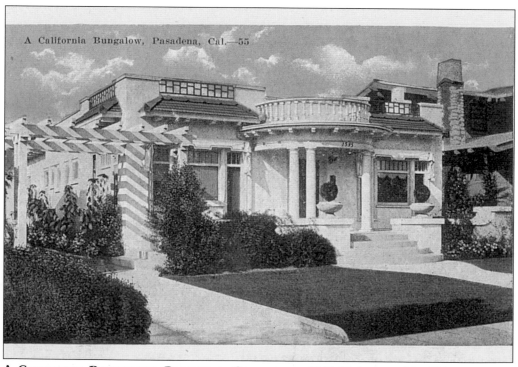

A CALIFORNIA BUNGALOW, PASADENA, CALIFORNIA. (P/P: Unknown. No. 55.)

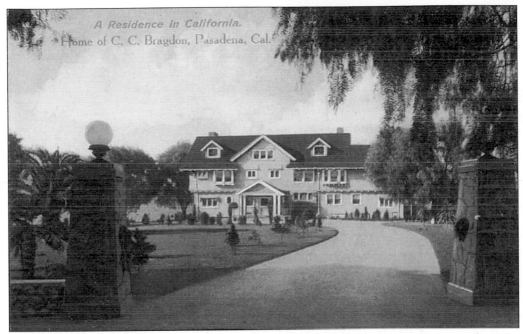

HOME OF C.C. BRAGDON, PASADENA, CALIFORNIA. (P/P: M. Rieder, Los Angeles. No. 4362. Made in Germany.)

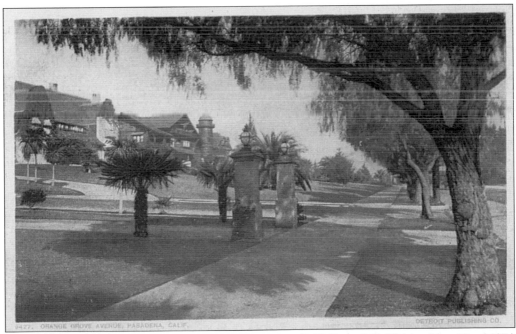

ORANGE GROVE AVENUE, PASADENA, CALIFORNIA. (P/P: Detroit Publishing Co., No. 9427.)

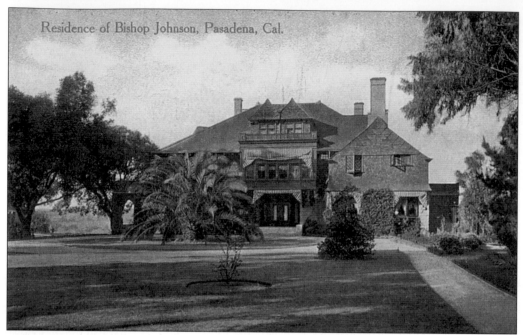

RESIDENCE OF BISHOP JOHNSON, PASADENA, CALIFORNIA. (P/P: M. Rieder. Los Angeles. No. 4523. Made in Germany.)

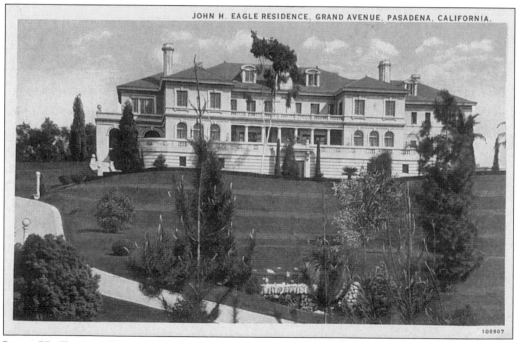

JOHN H. EAGLE, GRAND AVENUE, PASADENA, CALIFORNIA. (P/P: Western Publishing & Novelty Co., Los Angeles. No. 108907.)

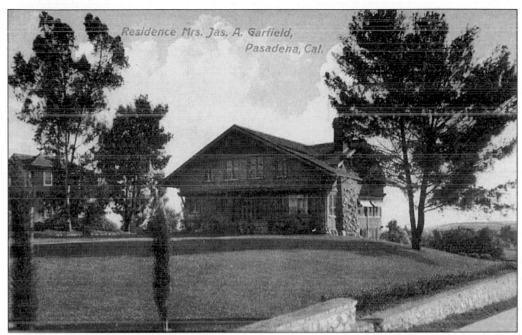

RESIDENCE OF MRS. JAMES A. GARFIELD, PASADENA, CALIFORNIA. Mrs. Garfield was the widow of slain president, James Garfield. (P/P: M. Rieder, Los Angeles. No. 4179. Made in Germany.)

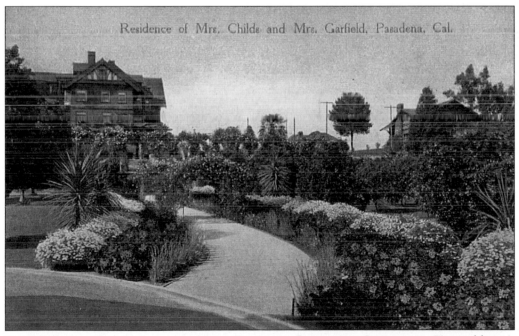

RESIDENCE OF MRS. CHILDS AND MRS. GARFIELD, PASADENA, CALIFORNIA. Pictured here is a private garden of a California home. (P/P: M. Rieder, Los Angeles. No. 4671. Made in Germany.)

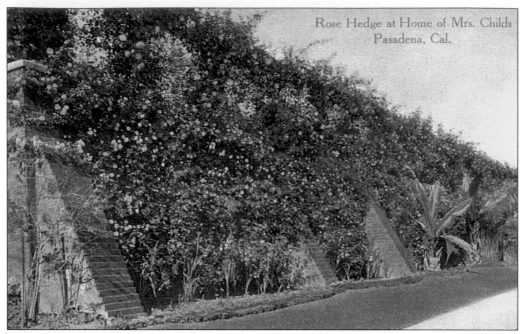

ROSE HEDGE AT HOME OF MRS. CHILDS, PASADENA, CALIFORNIA. A wall of roses is pictured above. (P/P: M. Rieder, Los Angeles. No. 4679. Made in Germany.)

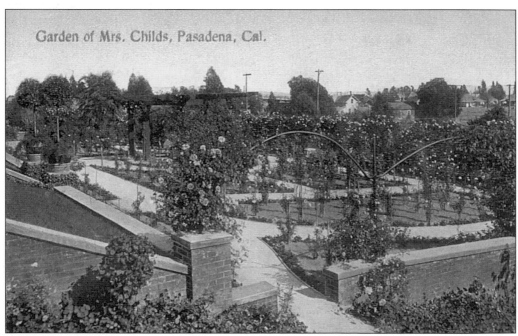

GARDEN OF MRS. CHILDS, PASADENA, CALIFORNIA. A California rose garden is shown above. (P/P: M. Rieder, Los Angeles. No. 4677. Made in Germany.)

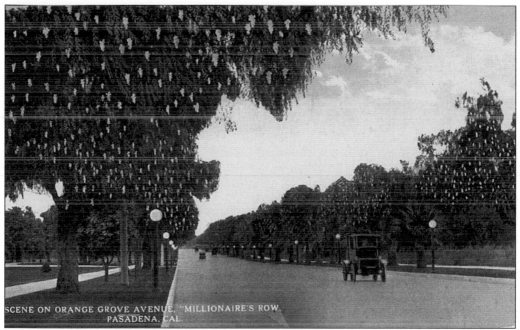

SCENE ON ORANGE GROVE AVENUE, "MILLIONAIRES ROW," PASADENA, CALIFORNIA.
(P/P: Carlin Post Card Co., Los Angeles. No. R34984.)

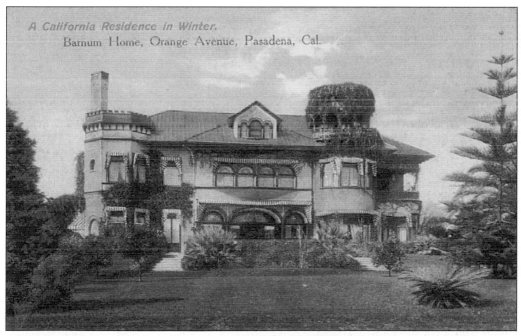

BARNUM HOME IN WINTER, ORANGE [GROVE] AVENUE, PASADENA, CALIFORNIA. (P/P:
M. Rieder, Los Angeles. No. 4365. Made in Germany.)

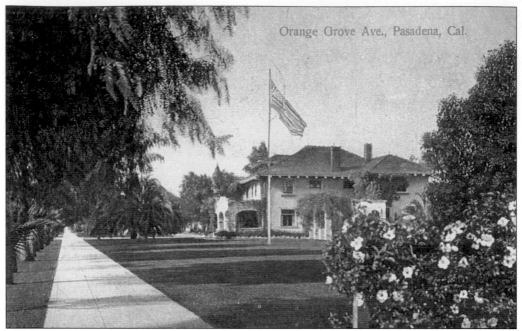

ORANGE GROVE AVENUE, PASADENA, CALIFORNIA. (P/P: Rieder, Los Angeles. No. 370. Made in Germany. Postmark: February 1908.)

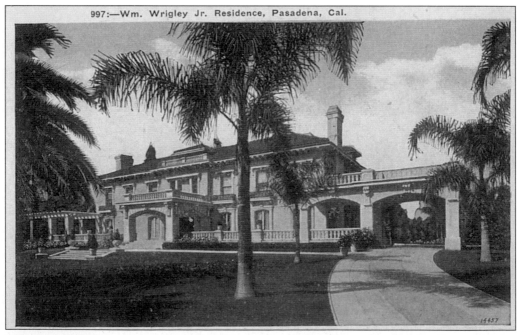

WILLIAM WRIGLEY JR. RESIDENCE, PASADENA, CALIFORNIA. One of the few remaining residences on "Millionaires Row," or Orange Grove Boulevard, this home was acquired by the Wrigleys in 1919. The Wrigley home is now the official home of the Pasadena Tournament of Roses Association. (P/P: M. Kashower, Los Angeles. No. 14457.)

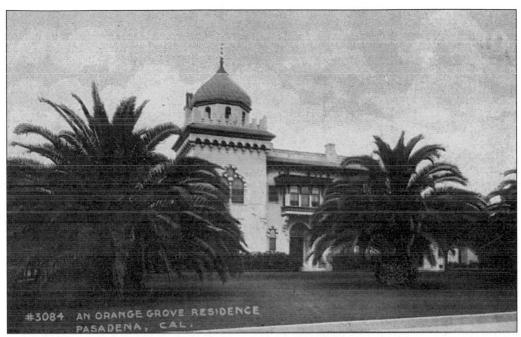

AN ORANGE GROVE RESIDENCE, PASADENA, CALIFORNIA. (P/P: CARDINELL-VINCENT CO., SAN FRANCISCO, OAKLAND, LOS ANGELES, SEATTLE. NO. 3084.)

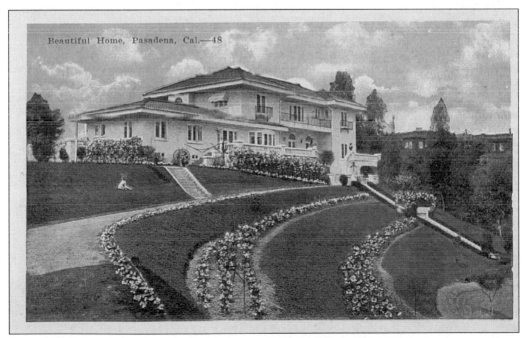

BEAUTIFUL HOME, PASADENA, CALIFORNIA. (P/P: Unknown. No. 48.)

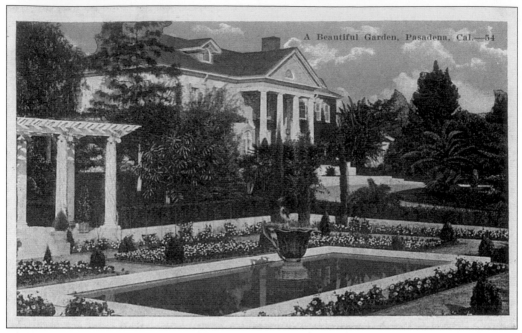

A Beautiful Garden, Pasadena, California. (P/P: Unknown. No. 54.)

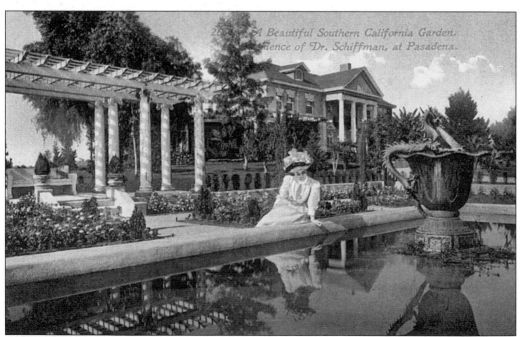

A Beautiful Southern California Garden. This was the residence of Dr. Schiffman at Pasadena. (P/P: Edward H. Mitchell, San Francisco. No. 2664.)

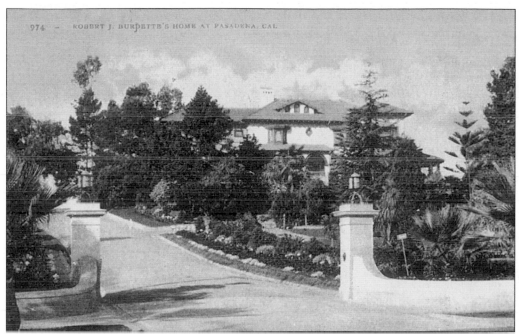

ROBERT J. BURDETTE'S HOME AT PASADENA, CALIFORNIA. The Burdette mansion was called Sunnycrest, and was famous for its views of the arroyo and the mountains. (P/P: Edward H. Mitchell, San Francisco. No. 974. Postmark: January 1908.)

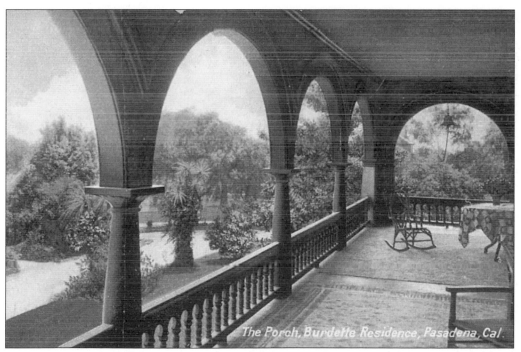

THE PORCH AT THE BURDETTE RESIDENCE, PASADENA, CALIFORNIA. (P/P: M. Rieder, Los Angeles. No. 4286. Made in Germany.)

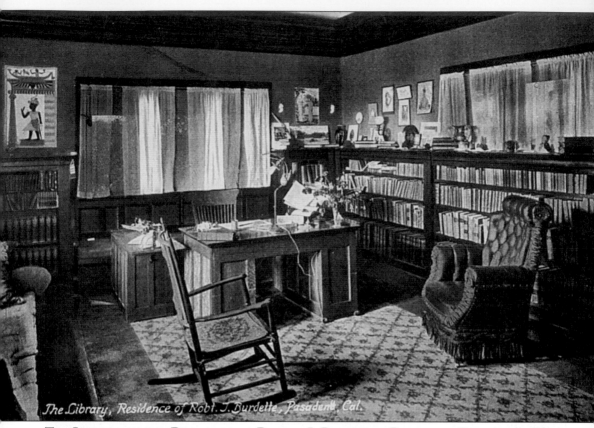

The Library, Residence of Robt. J. Burdette, Pasadena, Cal.

THE LIBRARY AT THE RESIDENCE OF ROBERT J. BURDETTE, PASADENA, CALIFORNIA. The following message was written but not posted: "Miss Bell Peterson, Rockford, Illinois. I expect one of these days you will be changing your name and there will be no more cards exchanged. RBS." (P/P: M. Rieder, Los Angeles. No. 4172. Made in Germany.)

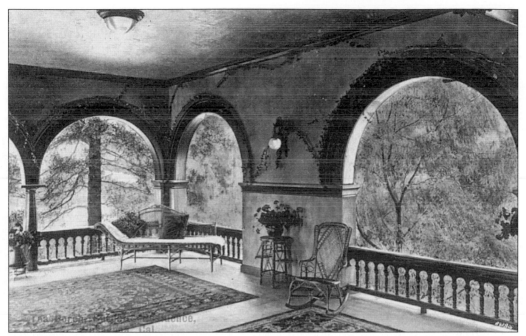

TEA PORCH, BURDETTE RESIDENCE, PASADENA, CALIFORNIA. Note the rugs on the porch floor. (P/P: M. Rieder, Los Angeles. No. 8934.)

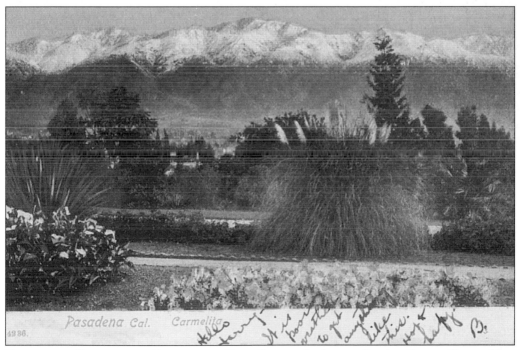

Pasadena Cal. Carmelita

PASADENA, CALIFORNIA, CARMELITA. Carmelita was the home of author Jeanne Carr and her husband, Dr. Ezra Carr. (P/P: Paul C. Koeber, New York & Kirchheim [Germany]. No. 4236. Postmark: August 1908.)

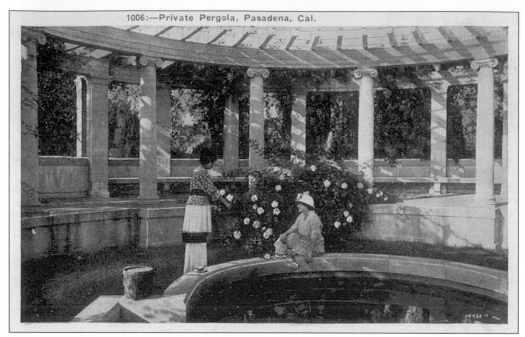

PRIVATE PERGOLA, PASADENA, CALIFORNIA. (P/P: M. Kashower, Los Angeles. No. 1006. Postmark: April 1924.)

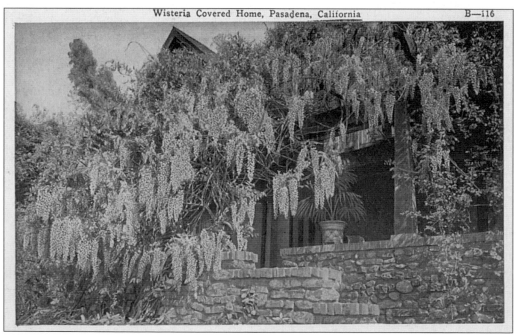

WISTERIA-COVERED HOME, PASADENA, CALIFORNIA. (P/P: Pacific Novelty Co., San Francisco & Los Angeles. No. B116.)

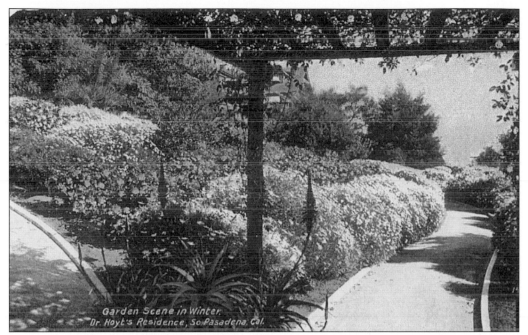

GARDEN SCENE IN WINTER AT DR. HOYT'S RESIDENCE IN SOUTH PASADENA, CALIFORNIA. (P/P: Benham Co., Los Angeles. No. 1484. Postmark: March 1910.)

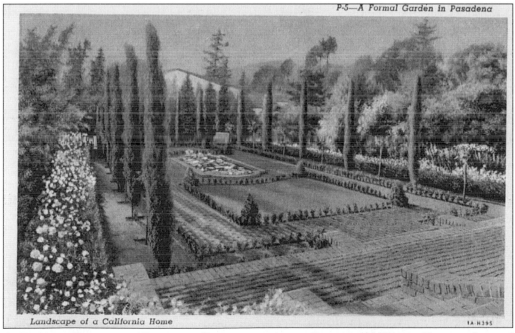

A FORMAL GARDEN IN PASADENA/LANDSCAPE OF A CALIFORNIA HOME. Text on the card reads: "Typical of many of the Southland's beautiful homes is this spacious garden of lawn, hedges, flowers and trees." (P/P: Western Publishing & Novelty Co., Los Angeles. No. P5.)

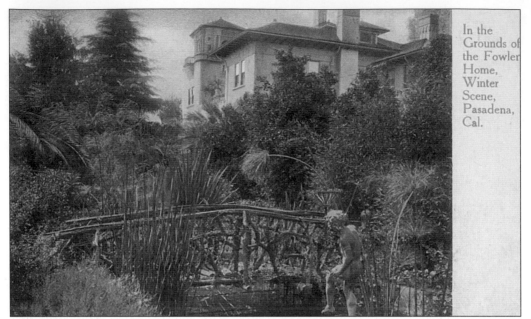

WINTER SCENE IN THE GROUNDS OF THE FOWLER HOME, PASADENA, CALIFORNIA. (P/P: M. Rieder, Los Angeles. No. 4536. Made in Germany. Postmark: August 1909.)

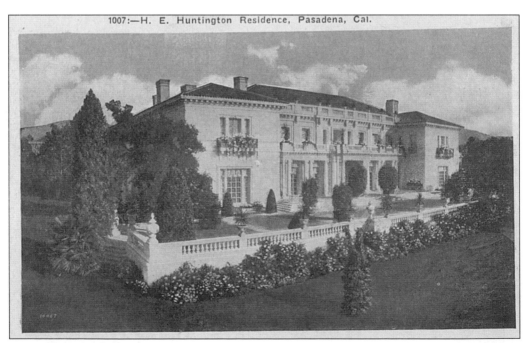

H.E. HUNTINGTON RESIDENCE, PASADENA, CALIFORNIA. (P/P: M. Kashower, Los Angeles. No. 1007.)

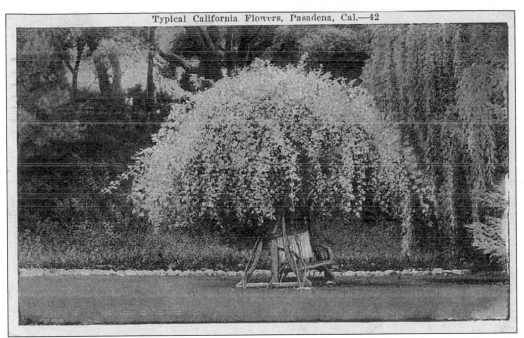

TYPICAL CALIFORNIA FLOWERS, PASADENA, CALIFORNIA. (P/P: Unknown. No. 42. Postmark: August 1922.)

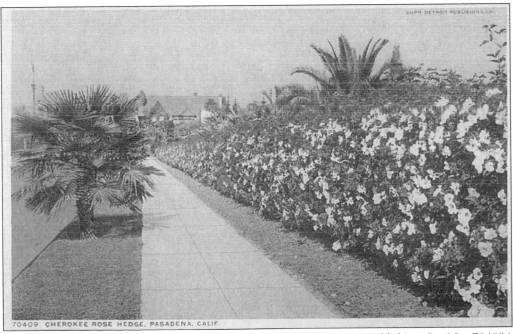

70409 CHEROKEE ROSE HEDGE, PASADENA, CALIF.

CHEROKEE ROSE HEDGE, PASADENA, CALIFORNIA. (P/P: Detroit Publishing Co. No. 70409.)

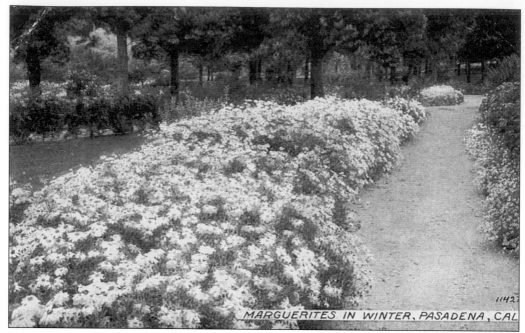

MARGUERITES IN WINTER, PASADENA, CALIFORNIA. (P/P: Acmegraph Co., Chicago. No. 11427.)

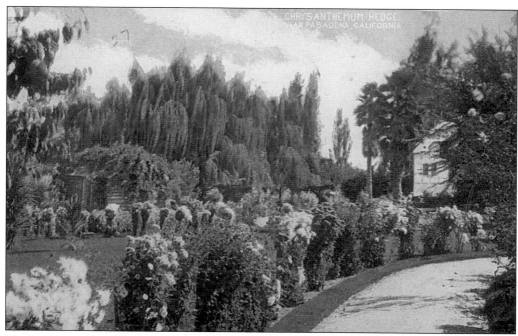

CHRYSANTHEMUM HEDGE NEAR PASADENA, CALIFORNIA. (P/P: Benham Indian Trading Co., Los Angeles. Postmark: February 1910.)

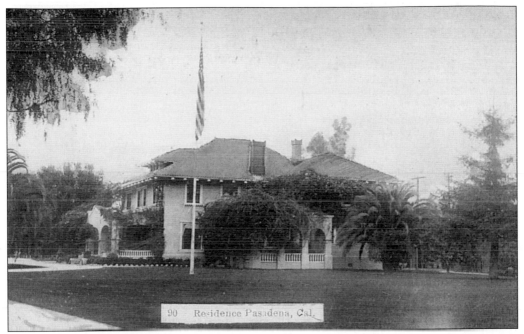

RESIDENCE, PASADENA, CALIFORNIA. (P/P: Globe Novelty Co., Los Angeles. No. 90. Made in Japan.)

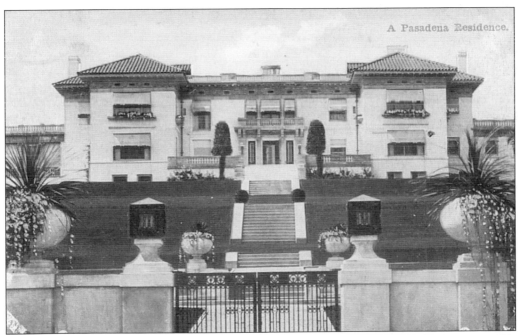

A PASADENA RESIDENCE. (P/P: The O. Newman Co., Los Angeles & San Francisco. No. B32. Postmark: August 1914.)

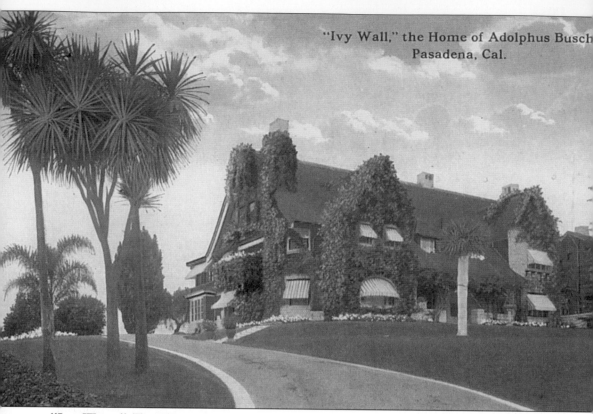

"Ivy Wall," the Home of Adolphus Busch
Pasadena, Cal.

"IVY WALL," THE HOME OF ADOLPHUS BUSCH, PASADENA, CALIFORNIA. This home was purchased at the turn of the century by St. Louis beer millionaire, Adolphus Busch, who died in 1913. (P/P: Carlin Post Card Co., Los Angeles. No. 1610.)

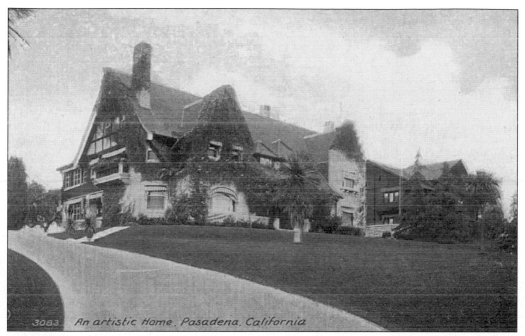

AN ARTISTIC HOME, PASADENA, CALIFORNIA. Mrs. Busch maintained the home until her death in 1928, and it remained in the family until the 1940s, when it was sold and demolished. (P/P: Unknown. No. 3083.)

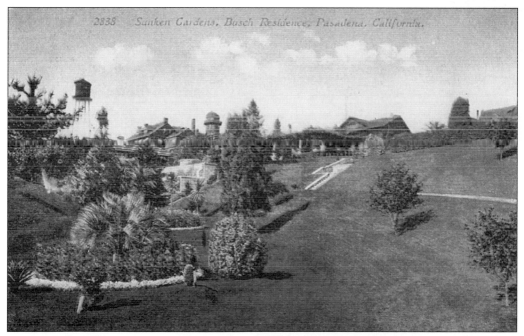

SUNKEN GARDENS, BUSCH RESIDENCE, PASADENA, CALIFORNIA. Busch Gardens was developed in 1905 and opened to the public in 1906. By 1910, it had become a major tourist attraction. (P/P: Souvenir Publishing Co., San Francisco. No. 2838.)

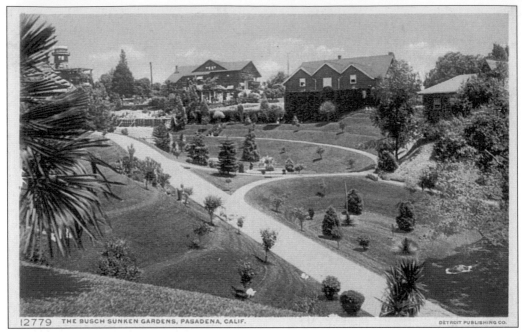

THE BUSCH SUNKEN GARDENS, PASADENA, CALIFORNIA. The gardens comprised about 30 acres of gardens, rolling lawn, and winding paths in the arroyo behind the Busch mansion. (P/P: Detroit Publishing Co. No. 12779.)

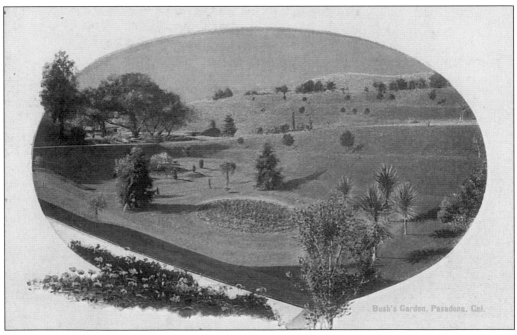

BUSH'S [*SIC*] GARDEN, PASADENA, CALIFORNIA. (P/P: Benham Co., Los Angeles. No. A8771.)

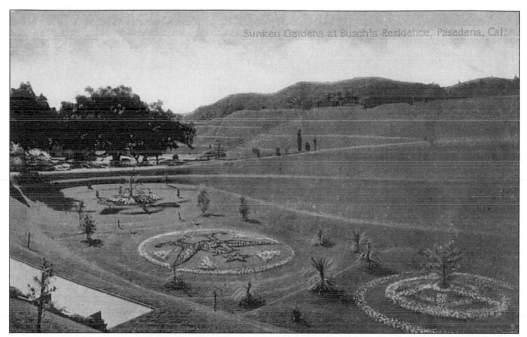

SUNKEN GARDEN AT BUSCH'S RESIDENCE, PASADENA, CALIFORNIA. The gardens were closed in the late 1930s. (P/P: Newman Postcard Co., Los Angeles. No. B11.)

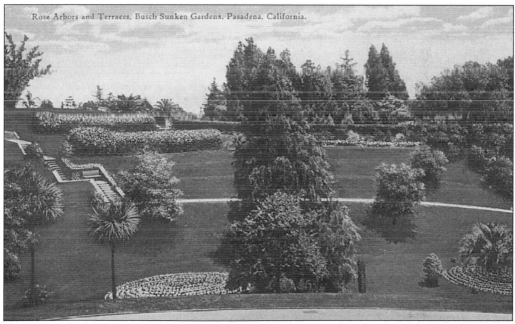

ROSE ARBORS AND TERRACES, BUSCH SUNKEN GARDENS, PASADENA, CALIFORNIA. (P/P: Western Publishing & Novelty Co., No. P29.)

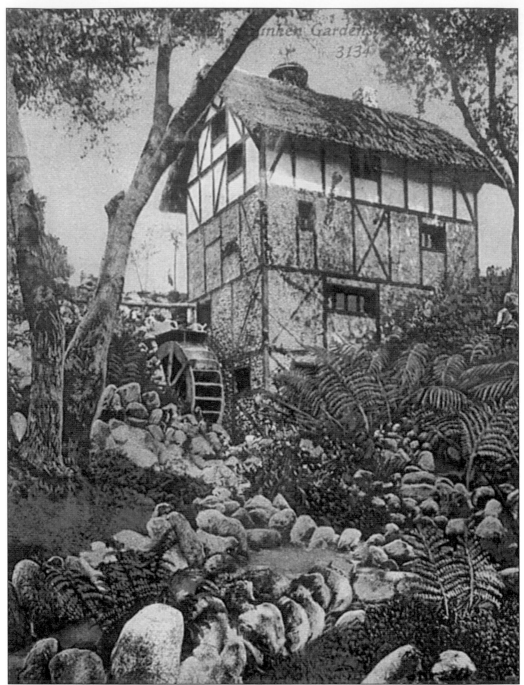

OLD BRICK MILL, BUSCH'S SUNKEN GARDENS, PASADENA, CALIFORNIA. The message on the card reads: "Dear cousins, I have been in Calif. three weeks. We are having a grand time. There is so many Iowa people hear we no and they take us in their auto and treat us fine. We went to the Pacific Ocean. It looks just like the Atlantic did. Oh, the nice seanery [*sic*] and beautifull [*sic*] flowers hear. The oranges are getting ripe....Wish you were hear. Celia." (P/P: Edward H. Mitchell, San Francisco. No. 3134. Postmark: December 1920.)

Bur Felsen Muehle, Busch Sunken Gardens, Pasadena, California. (P/P: Western Publishing & Novelty Co., Los Angeles. No. P28. Handwritten date: January 1927.)

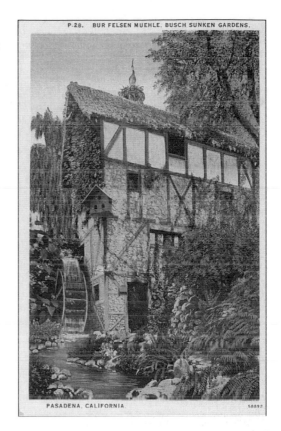

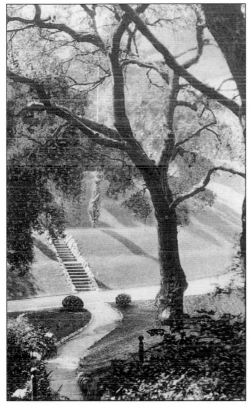

In the Busch Gardens, Pasadena, California. (P/P: Sunny Scenes, Inc., Winter Park, Florida. No. 2000–48. Handwritten note: Bought in 1932.)

45

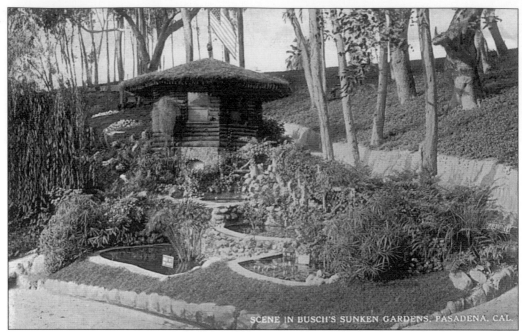

SCENE IN BUSCH'S SUNKEN GARDENS, PASADENA, CALIFORNIA. (P/P: Carlin Post Card Co., Los Angeles. No. 1613.)

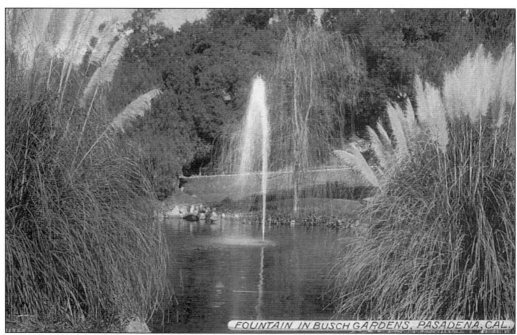

FOUNTAIN IN BUSCH GARDENS, PASADENA, CALIFORNIA. (P/P: Acmegraph Co., Chicago. No. 11365.)

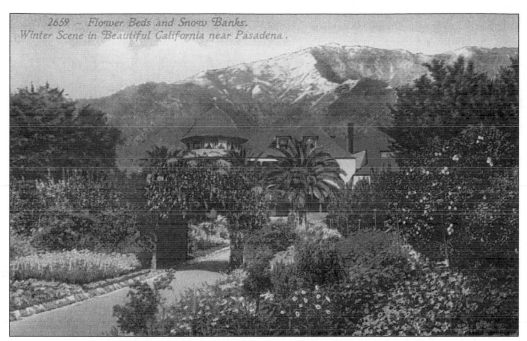

FLOWER BEDS AND SNOW BANKS/WINTER SCENE IN BEAUTIFUL CALIFORNIA, NEAR PASADENA [MCNALLY MANSION, ALTADENA]. (P/P: Edward H. Mitchell, San Francisco. No. 2659. Postmark: March 1912.)

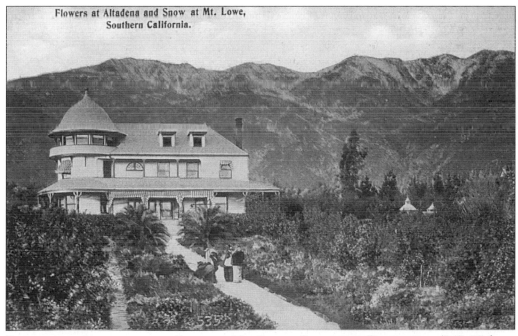

FLOWERS AT ALTADENA AND SNOW AT MT. LOWE, SOUTHERN CALIFORNIA. (P/P: Tichnor Bros., Boston & Los Angeles.)

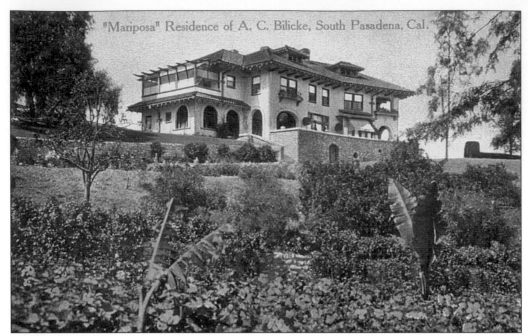

"Mariposa," Residence of A.C. Belicke, South Pasadena, California. (P/P: M. Rieder, Los Angeles. No, 4540. Made in Germany.)

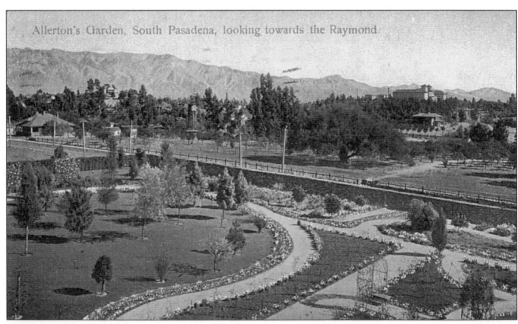

Allerton's Garden, South Pasadena, Looking Towards the Raymond. The message on this card states: "Mabel Van Dusen, at Smith College in North Hampton, Mass., Dear Mabel, This is the way it looks out here in January. I have just been reading the daily papers about your cold weather. We are picking strawberries and going bathing. Today was a beautiful 'June' day, All well. Papa." (P/P: M. Rieder, Los Angeles. No. 4528. Made in Germany. Postmark: November 1908.)

Three
BUILDINGS AND CHURCHES

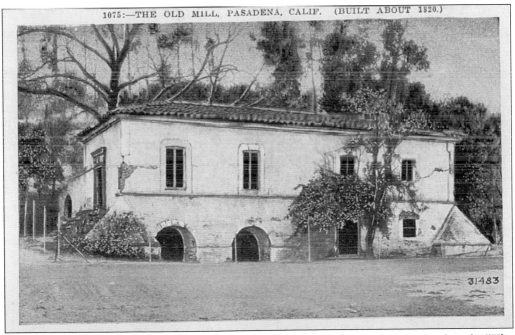

1075:—THE OLD MILL, PASADENA, CALIF. (BUILT ABOUT 1820.)

31483

THE OLD MILL, PASADENA, CALIFORNIA. (Built about 1820.) Text on the card reads: "The Old Mill (El Molino Viejo) was built for Jose Maria de Zalvida, padre of San Gabriel, by Joseph Chapman, first American to settle in California in 1818." (P/P: M. Kashower, Los Angeles. No. 31483.)

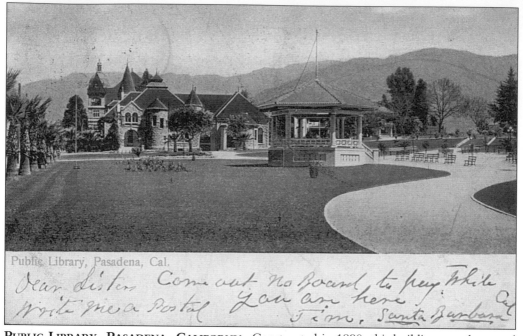

Public Library, Pasadena, Cal.

Dear Sister Come out No Board, to pay While you are here. Write me a Postal Tom, Santa Barbara Cal

PUBLIC LIBRARY, PASADENA, CALIFORNIA. Constructed in 1890, this building was destroyed by an earthquake in 1933. (P/P: M. Rieder, Los Angeles. Made in Germany. Undivided back. Postmark: December 1905.)

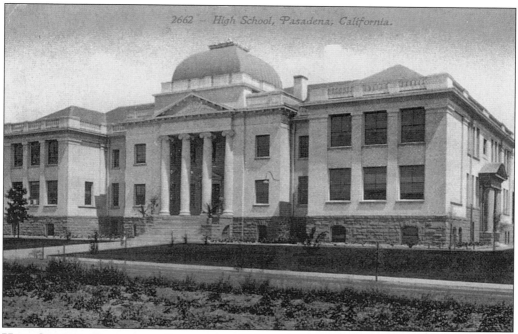

2662 — High School, Pasadena, California.

HIGH SCHOOL, PASADENA, CALIFORNIA. This structure was built in 1904. (P/P: Edward H. Mitchell, San Francisco. No. 2662.)

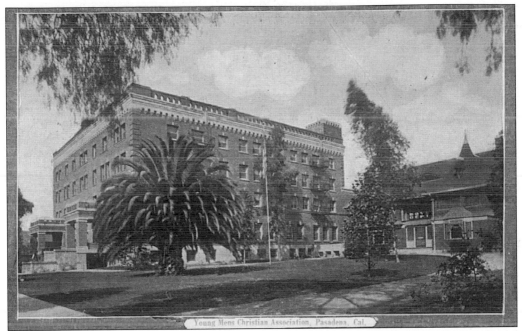

YOUNG MEN'S CHRISTIAN ASSOCIATION, PASADENA, CALIFORNIA. (P/P: Engraved and printed by Pasadena Stationery & Printing Co.)

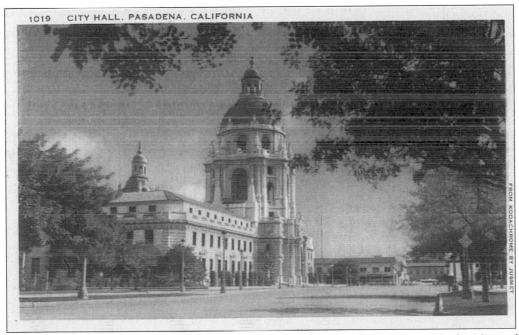

CITY HALL, PASADENA, CALIFORNIA. Text on this card reads: "The outstanding building of Pasadena's Civic Center is the magnificent City Hall, a gem of Spanish-style architecture in a setting of tropical trees, shrubs and flowers." (P/P: Longshaw Card Co., Los Angeles. No. 1019.)

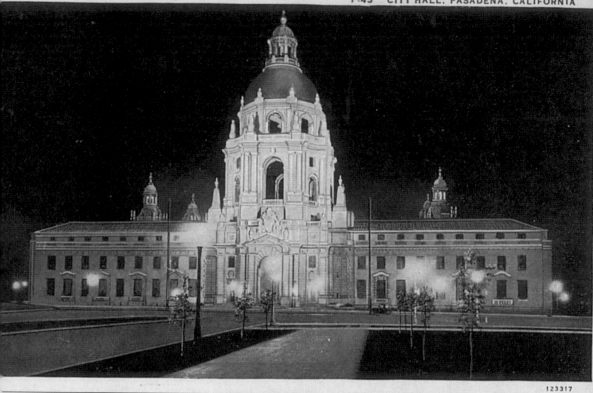

123317

CITY HALL, PASADENA, CALIFORNIA, ILLUMINATED AT NIGHT. (P/P: Western Publishing & Novelty Co., Los Angeles. No. 43.)

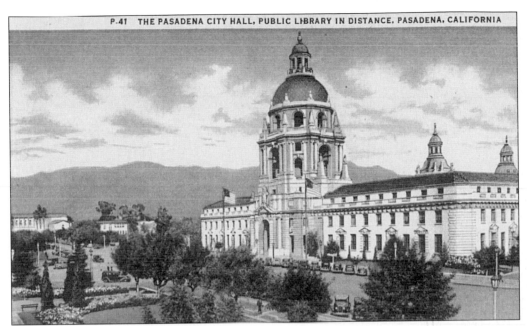

THE PASADENA CITY HALL, PUBLIC LIBRARY IN DISTANCE, PASADENA, CALIFORNIA. Text on the card states: "A beautiful edifice in the heart of Pasadena's Civic Center, which houses the directors of the city government. In the distance may be seen Pasadena's twin peaks, Mt. Lowe and Mt. Wilson, two of California's chief attractions." (P/P: Western Publishing & Novelty Co., Los Angeles. No. P41.)

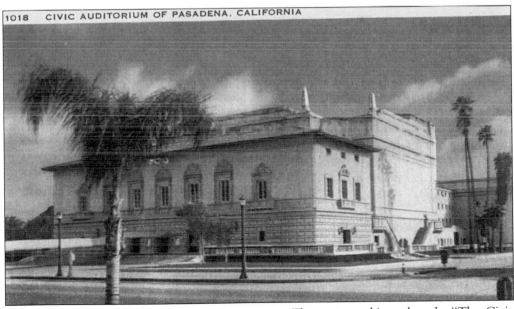

1018 CIVIC AUDITORIUM OF PASADENA, CALIFORNIA

CIVIC AUDITORIUM OF PASADENA, CALIFORNIA. The text on this card reads: "The Civic Auditorium (costing $1,250,000) is especially noted for the dances given by top-ranking orchestras, where over 3,000 may dance in the large Exhibition Hall. The theatre, which is used for operas, concerts and lectures, seats 3,000 persons." (P/P: Longshaw Card Co., Los Angeles. No. 1018.)

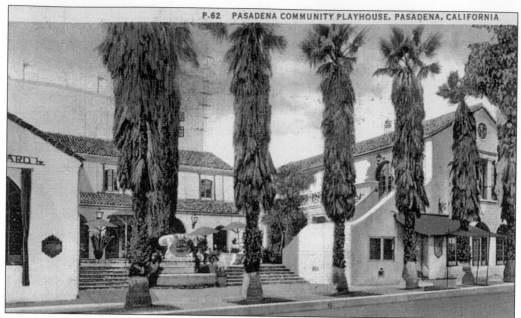

PASADENA COMMUNITY PLAYHOUSE, PASADENA, CALIFORNIA. Text on the card reads: "The Pasadena Community Playhouse is considered the outstanding community theatre of the country and enjoys an international reputation for the excellence and variety of productions." (P/P: Western Publishing & Novelty Co., Los Angeles. No. P62. Postmark: December 1946.)

THE CALIFORNIA INSTITUTE OF TECHNOLOGY, PASADENA, CALIFORNIA. Text on this card states: "'Cal Tech' is one of the foremost of American institutions devoted to technical education and research. Here was entrusted the delicate work of finishing the 200 inch glass of the largest telescope in the world of Palomar Mountain." (P/P: Longshaw Card Co., Los Angeles. From Kodachrome for Jusmet. No. 1015.)

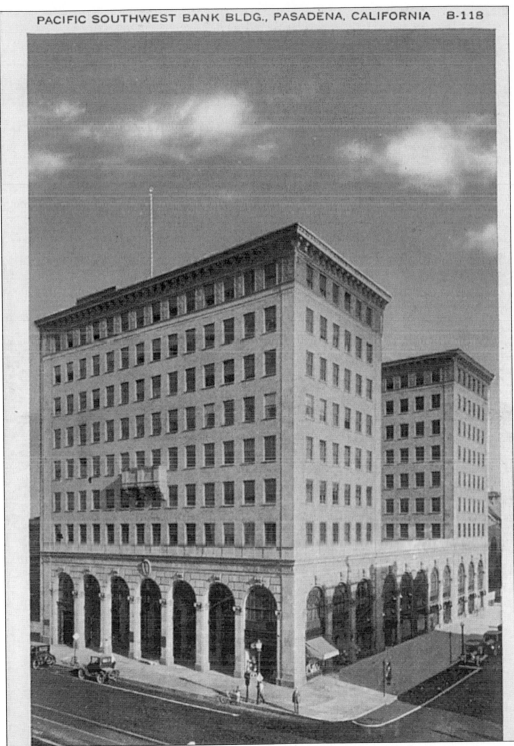

PACIFIC SOUTHWEST BANK BUILDING, PASADENA, CALIFORNIA. (P/P: Pacific Novelty Co., San Francisco & Los Angeles. No. B118.)

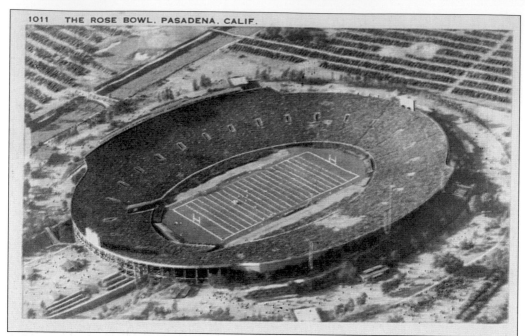

THE ROSE BOWL, PASADENA, CALIFORNIA. Text on the card reads: "The famous Rose Bowl is the scene of many attractions during the year, the most outstanding of which is the New Year's Day college football game. The teams representing the best of East and West meet here, and this is considered the climax of the football season." (P/P: Longshaw Card Co., Los Angeles. No. 1011. Postmark: February 1954.)

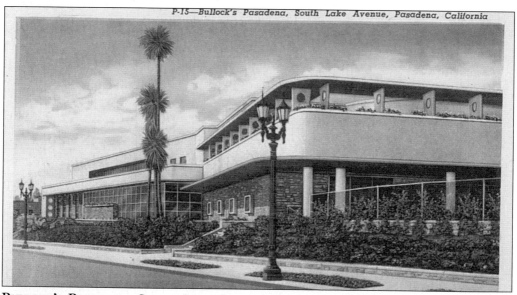

P-15—Bullock's Pasadena, South Lake Avenue, Pasadena, California

BULLOCK'S PASADENA, SOUTH LAKE AVENUE, PASADENA, CALIFORNIA. Text on this card states: "A department store of distinction, and one of the most unusual and beautiful establishments in the entire country. The architecture is ultra-modern, of the very latest design, outwardly having an appearance of a fine hotel or an exclusive club." (P/P: Western Publishing & Novelty Co., Los Angeles. No. P15.)

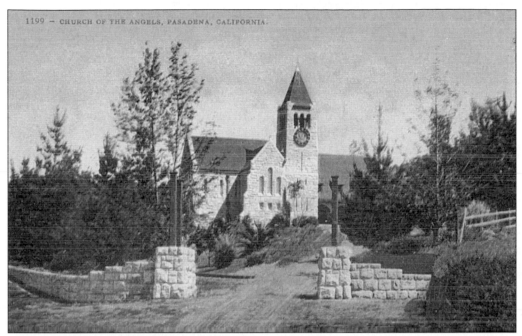

CHURCH OF THE ANGELS, PASADENA, CALIFORNIA. This structure was completed in 1889. (P/P: Edward H. Mitchell, San Francisco. No. 1199.)

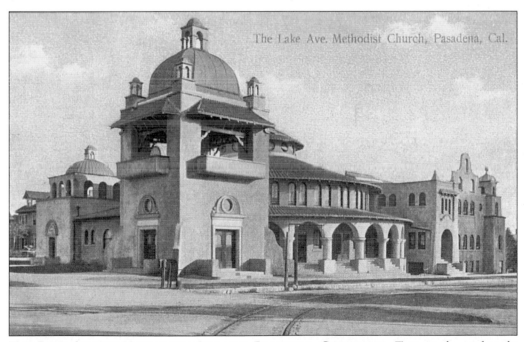

The Lake Ave. Methodist Church, Pasadena, Cal.

THE LAKE AVENUE METHODIST CHURCH, PASADENA, CALIFORNIA. Text on the card reads: "'The Crown of the Valley.' Pasadena is the favorite of tourists and sojourners from the east and is the city of homes. There many handsome churches and the educational advantages are exceptional. The hotels are the best known in the country." (P/P: M. Rieder, Los Angeles. No. 5008. Made in Germany.)

ALL SAINTS CHURCH (EPISCOPAL), PASADENA, CALIFORNIA. (P/P: Edward H. Mitchell, San Francisco. No. 2665.)

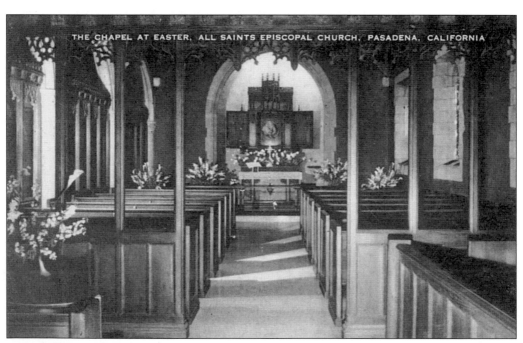

THE CHAPEL AT EASTER, ALL SAINTS EPISCOPAL CHURCH, PASADENA, CALIFORNIA

THE CHAPEL AT EASTER, ALL SAINTS EPISCOPAL CHURCH, PASADENA, CALIFORNIA. (P/P: Artvue Post Card Co., New York.)

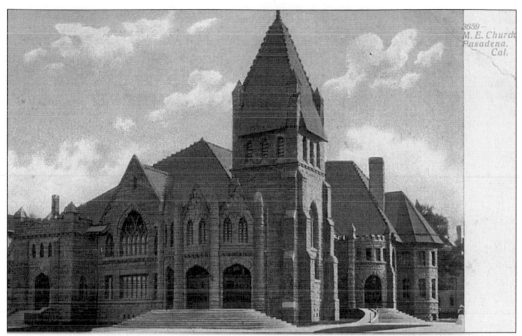

M.E. Church, Pasadena, California. (P/P: Adolph Selige Publishing Co., St. Louis, Leipzig, Berlin. No. 3659. Printed in Germany.)

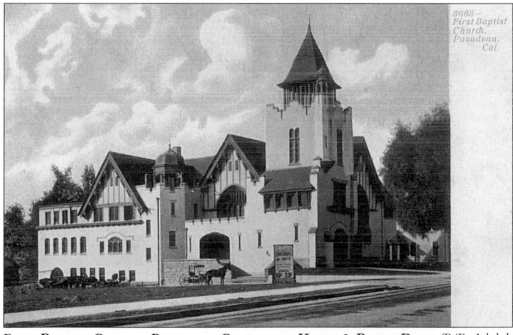

First Baptist Church, Pasadena, California, Horse & Buggy Days. (P/P: Adolph Selige, St. Louis, Leipzig, Berlin. Printed in Germany. Undivided back.)

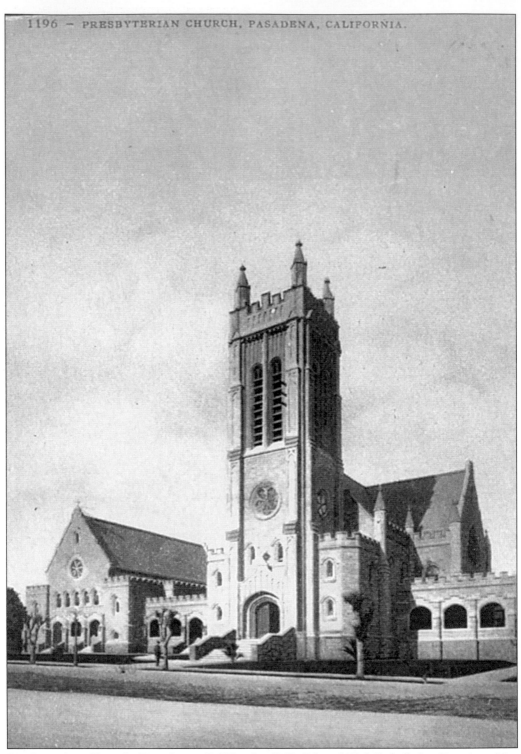

Presbyterian Church, Pasadena, California. (P/P: Edward H. Mitchell, San Francisco. No. 1196. Postmark: March 1911.)

ST. ANDREWS ROMAN CATHOLIC CHURCH, PASADENA, CALIFORNIA. (P/P: Edward H. Mitchell, San Francisco. No. 2650.)

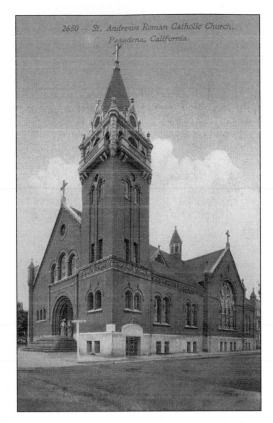

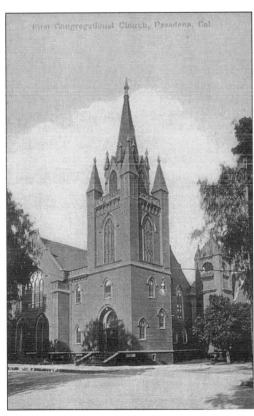

FIRST CONGREGATIONAL CHURCH, PASADENA, CALIFORNIA. (P/P: Newman Post Card Co., Los Angeles. No. B32. Made in Germany.)

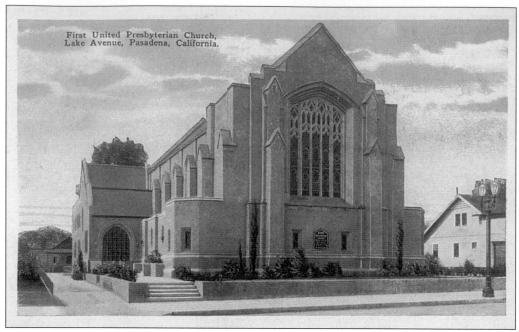

FIRST UNITED PRESBYTERIAN CHURCH, LAKE AVENUE, PASADENA, CALIFORNIA. (P/P: California Greeting & Post Card Co., Los Angeles. No. 330N.)

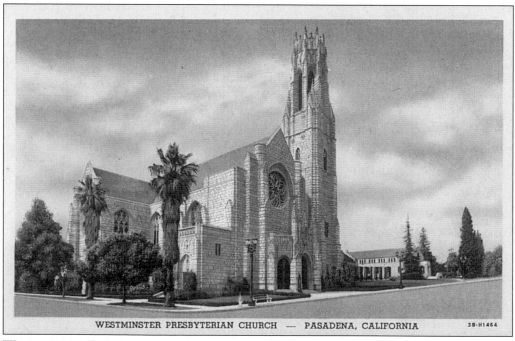

WESTMINSTER PRESBYTERIAN CHURCH, PASADENA, CALIFORNIA. Text on this card reads: "This French-Gothic edifice is one of the most beautiful Protestant churches in the Pacific Coast area." (P/P: Curteich, Chicago. No. 3B-Hi464.)

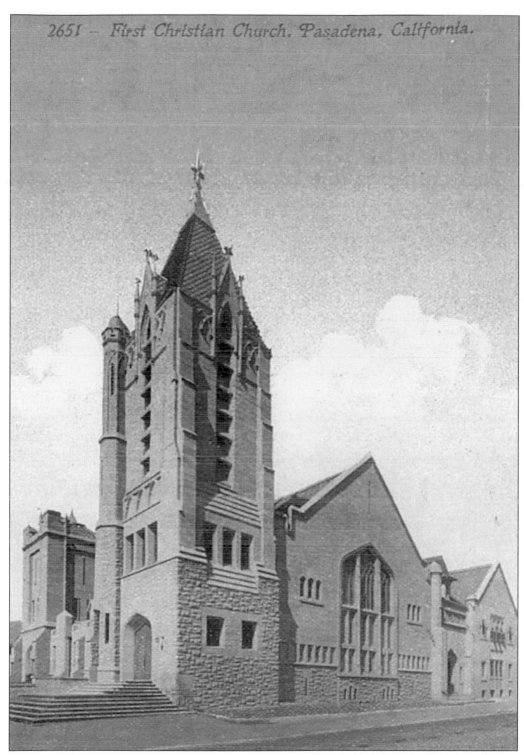

2651 — First Christian Church, Pasadena, California.

FIRST CHRISTIAN CHURCH, PASADENA, CALIFORNIA. (P/P: Edward H. Mitchell, San Francisco. No. 2651.)

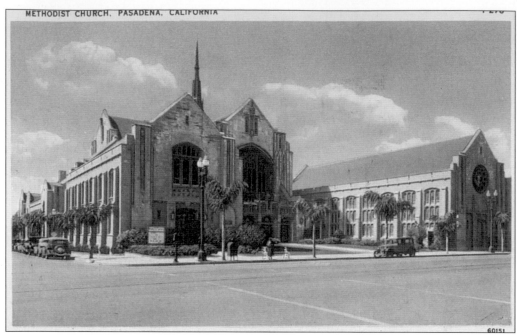

METHODIST CHURCH, PASADENA, CALIFORNIA. (P/P: Tichnor Art Co., Los Angeles. No. T278. Postmark: June 1940.)

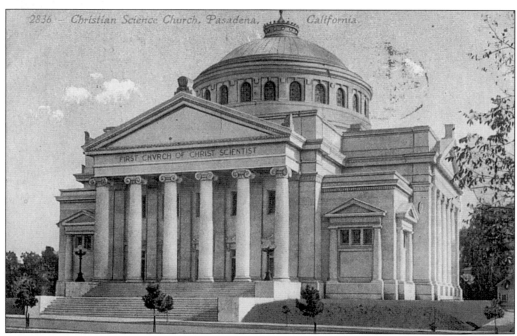

CHRISTIAN SCIENCE CHURCH, PASADENA, CALIFORNIA. (P/P: Edward H. Mitchell, San Francisco. No. 2836. Postmark: June 1912.)

Four

PARKS, STREETS, AND ROADS

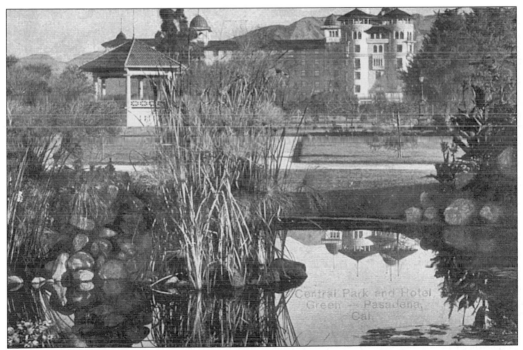

CENTRAL PARK AND HOTEL GREEN, PASADENA, CALIFORNIA. (P/P: Newman Post Card Co., Los Angeles, Leipzig, Halberstadt. Made in Germany.)

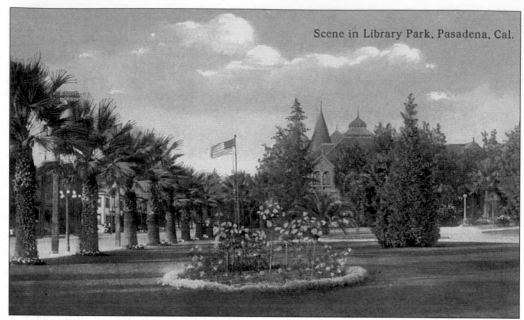

SCENE IN LIBRARY PARK, PASADENA, CALIFORNIA. (P/P: Carlin Post Card Co., Los Angeles. No. 1632.)

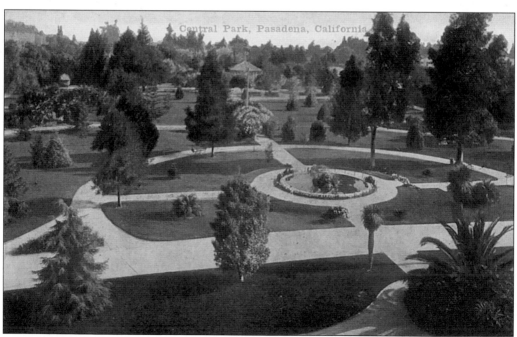

CENTRAL PARK, PASADENA, CALIFORNIA. This was Pasadena's first park. (P/P: Van Ornum Colorprint Co., Los Angeles. No. 578.)

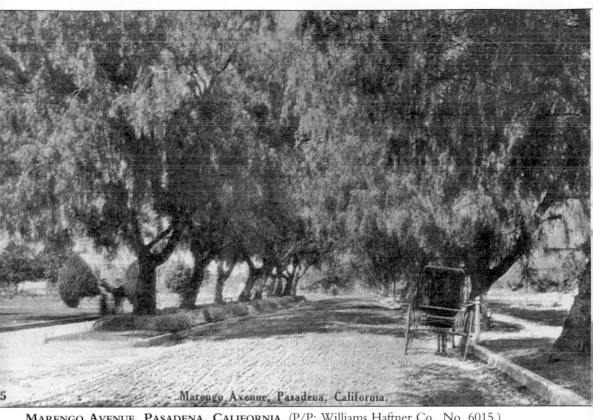

MARENGO AVENUE, PASADENA, CALIFORNIA. (P/P: Williams Haftner Co., No. 6015.)

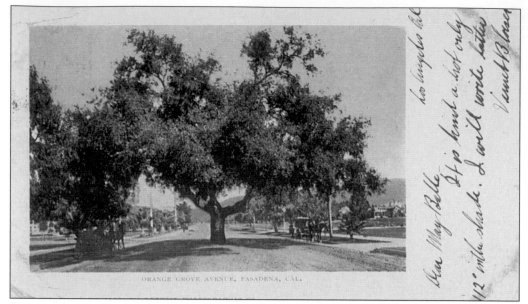

ORANGE GROVE AVENUE, PASADENA, CALIFORNIA. The message on this card states: "It's kind of hot today. 112 in the shade." (P/P: Detroit Photographic, Copyright 1902. No. 6110. Undivided back. Postmark: September.)

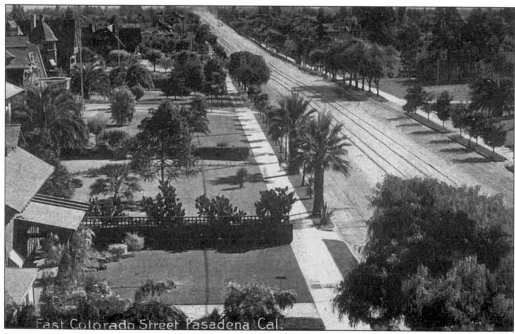

EAST COLORADO STREET, PASADENA, CALIFORNIA. (P/P: Newman Post Card Co., Los Angeles. No. 5110. Made in Germany. Postmark: November 1908.)

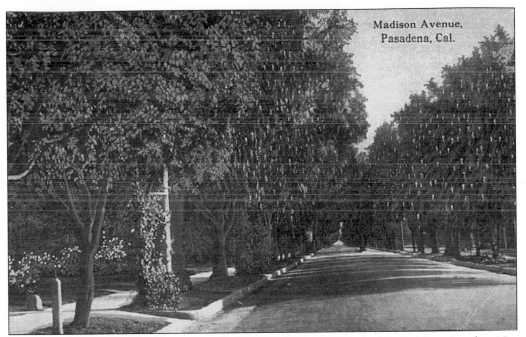

MADISON AVENUE, PASADENA, CALIFORNIA. (P/P: Carlin Post Card Co., Los Angeles. No. 1625. Postmark: August 1915.)

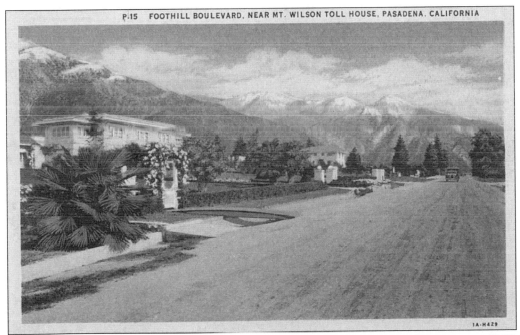

FOOTHILL BOULEVARD NEAR MT. WILSON TOLL HOUSE, PASADENA, CALIFORNIA. (P/P: Western Publishing & Novelty Co., Los Angeles. No. P15.)

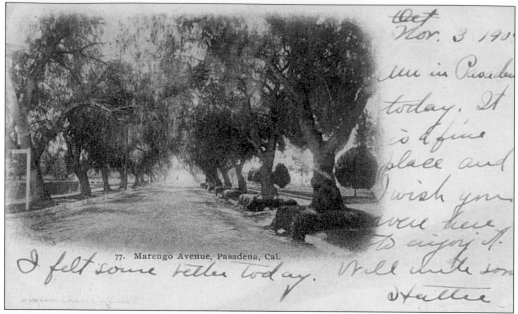

Handwritten on postcard:
Oct
Nov. 3 190[?]

Am in Pasadena today. It is a fine place and I wish you were here to enjoy it. Will write soon. Hattie

77. Marengo Avenue, Pasadena, Cal.

I felt some better today.

MARENGO AVENUE, PASADENA, CALIFORNIA. (P/P: Edward H. Mitchell, San Francisco. No. 77. Private Mailing Card. Undivided back. Postmark: November 1904.)

MARENGO AVENUE, PASADENA, CALIFORNIA. (P/P: Edward H. Mitchell, San Francisco. No. 77.)

THE TWIN PALMS BY NIGHT, PASADENA, CALIFORNIA. (P/P: Carlin Post Card Co., No. 1633.)

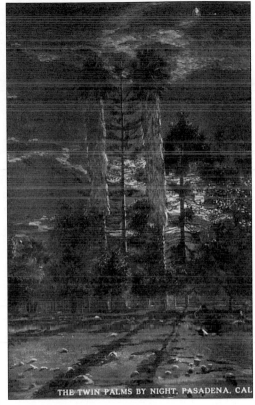

THE TWIN PALMS BY NIGHT, PASADENA, CAL

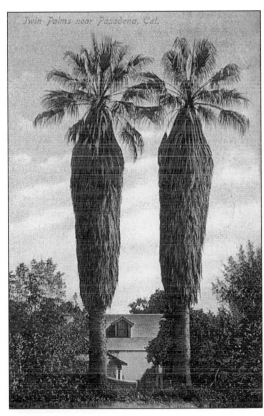

TWIN PALMS, NEAR PASADENA, CALIFORNIA. (P/P: Newman Post Card Co., Los Angeles. No. B57. Made in Germany. Postmark: December 1910.)

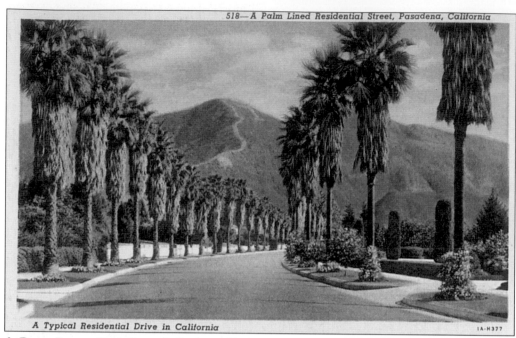

518—A Palm Lined Residential Street, Pasadena, California

A Typical Residential Drive in California

A Palm Lined Residential Street, Pasadena, California. This is a typical residential drive in California. (P/P: Western Publishing & Novelty Co., Los Angeles. No. 518.)

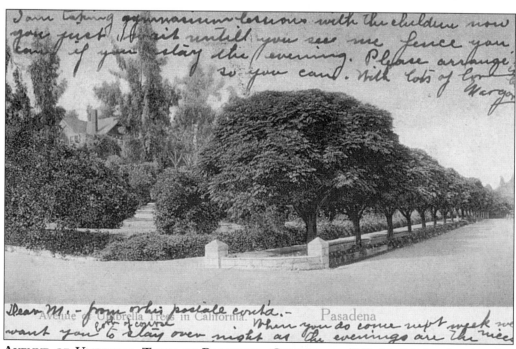

Avenue of Umbrella Trees in Pasadena, California. (P/P: M. Rieder, Los Angeles. No. 137. Made in Germany. Postmark: September 1905.)

MARENGO AVENUE, PASADENA, CALIFORNIA. (P/P: M. Rieder, Los Angeles. No. 3780. Made in Germany. Postmark: October 1907.)

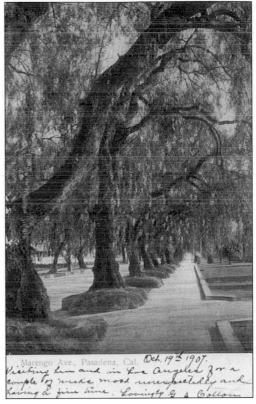

Marengo Ave., Pasadena, Cal. *Oct. 19th 1907.*
Visiting here and in Los Angeles for a couple of weeks most unexpectedly and having a fine time. Lovingly G A Colton

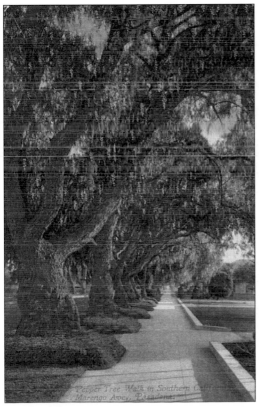

Pepper Tree Walk in Southern California
Marengo Ave., Pasadena.

PEPPER TREE WALK ON MARENGO AVENUE IN PASADENA, CALIFORNIA. (P/P: Edward H. Mitchell, San Francisco. No. 2660. Postmark: April 1912.)

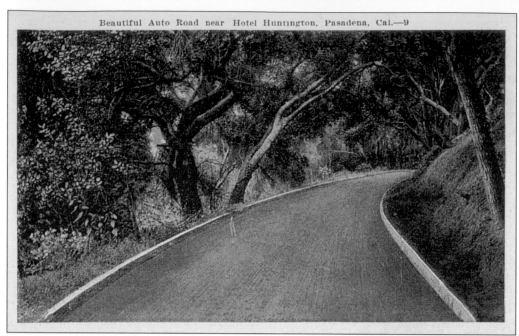

BEAUTIFUL AUTO ROAD NEAR HOTEL HUNTINGTON, PASADENA, CALIFORNIA. (P/P: Unknown. No. 9.)

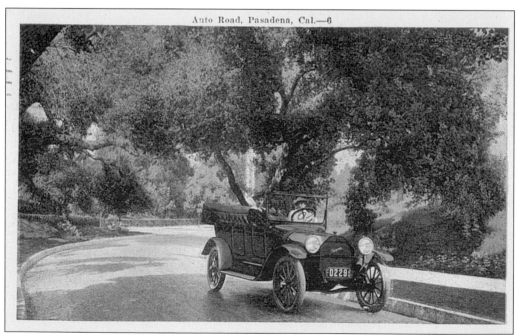

AUTO ROAD, PASADENA, CALIFORNIA. (P/P: Unknown. No. 6. Postmark: February 1924.)

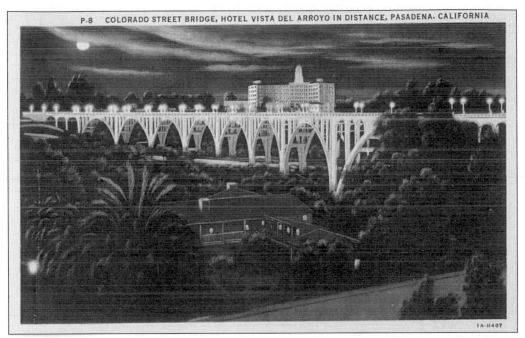

COLORADO STREET BRIDGE, HOTEL VISTA DEL ARROYO IN DISTANCE, PASADENA, CALIFORNIA. (P/P: Western Publishing & Novelty Co., Los Angeles. No. P8. Postmark: December 1944.)

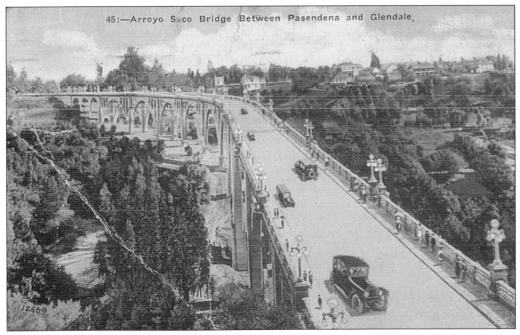

ARROYO SECO BRIDGE BETWEEN PASADENA AND GLENDALE. (P/P: M. Kashower, Los Angeles. No. 45. May 1924.)

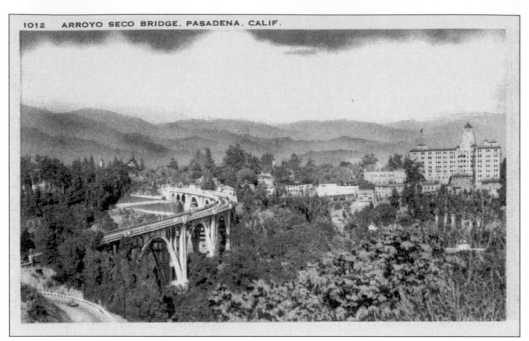

ARROYO SECO BRIDGE, PASADENA, CALIFORNIA. Text on this card reads: "Spanning the Arroyo Seco is the Colorado Street Bridge, considered one of the most beautiful bridges in the world, it rises 150 feet from the bed of the arroyo and curves its graceful length for 1,460 ft to form a connecting link of the inland highways." (P/P: Longshaw Card Co., Los Angeles. No. 1012.)

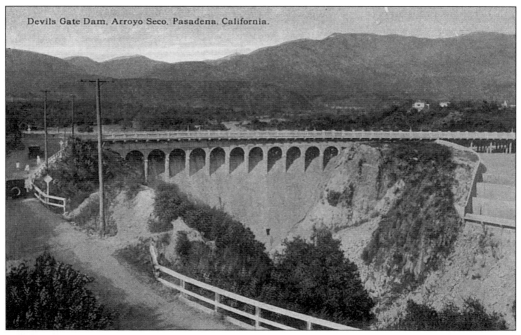

Devils Gate Dam, Arroyo Seco, Pasadena, California.

DEVILS GATE DAM, ARROYO SECO, PASADENA, CALIFORNIA. (P/P: Western Publishing & Novelty Co., Los Angeles. No. P16.)

Five

PASADENA VIEWS
AND THE
TOURNAMENT OF ROSES

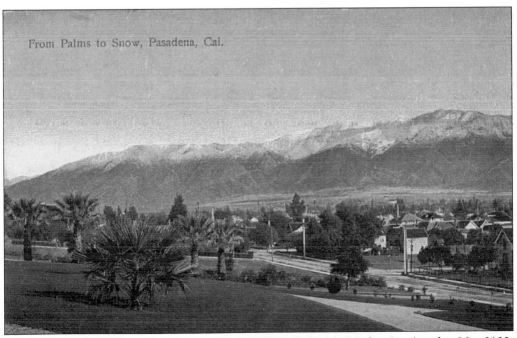

FROM PALMS TO SNOW, PASADENA, CALIFORNIA. (P/P: M. Rieder, Los Angeles. No. 3132. Made in Germany.)

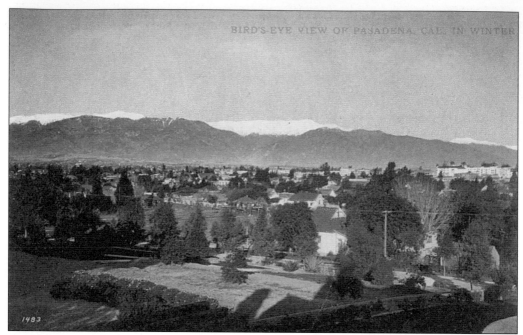

BIRD'S-EYE VIEW OF PASADENA, CALIFORNIA, IN WINTER. (P/P: Benham Co., Los Angeles. No. 1483.)

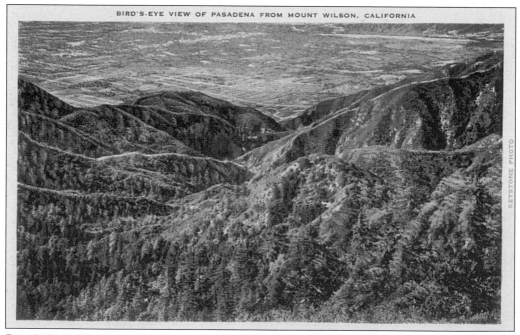

BIRD'S-EYE VIEW OF PASADENA FROM MOUNT WILSON, CALIFORNIA. (P/P: E. Kropp, Milwaukee. No. 17500N.)

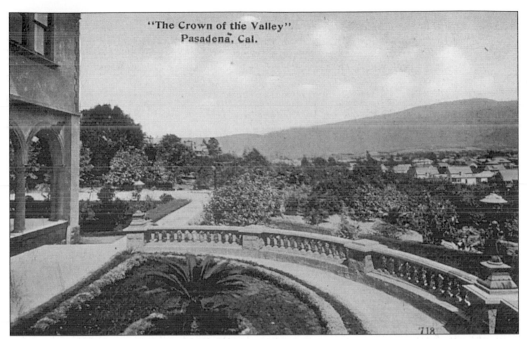

"THE CROWN OF THE VALLEY," PASADENA, CALIFORNIA. (P/P: Tichnor Bros., Boston & Los Angeles. No. 718.)

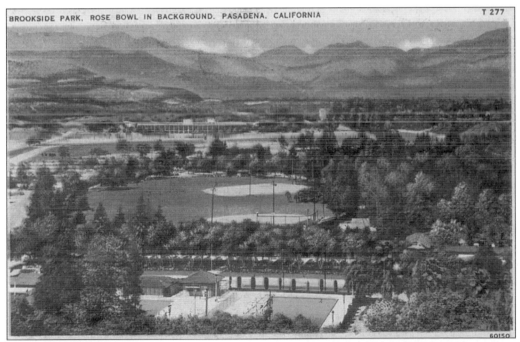

BROOKSIDE PARK, ROSE BOWL IN BACKGROUND, PASADENA, CALIFORNIA. (P/P: Tichnor Art Co., Los Angeles. No. T277. Postmark: July 1937.)

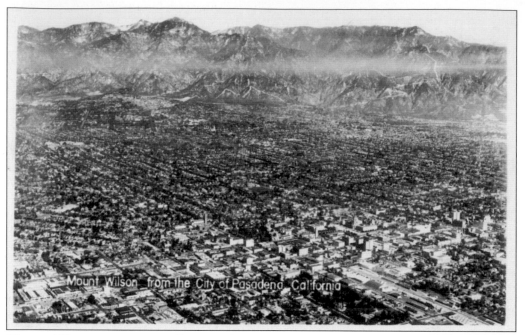

MOUNT WILSON FROM THE CITY OF PASADENA, CALIFORNIA. (P/P: Los Angeles Photo Post Card Co.)

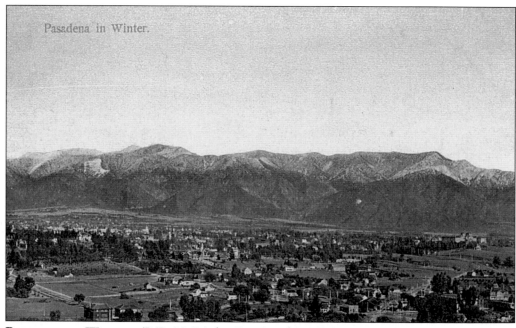

PASADENA IN WINTER. (P/P: M. Rieder, Los Angeles & Leipzig. No. 3300.)

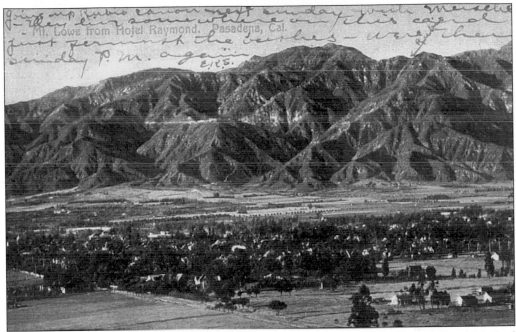

MT. LOWE FROM HOTEL RAYMOND, PASADENA, CALIFORNIA. (P/P: Newman Post Card Co., Los Angeles. No. C13. Postmark: September 1908.)

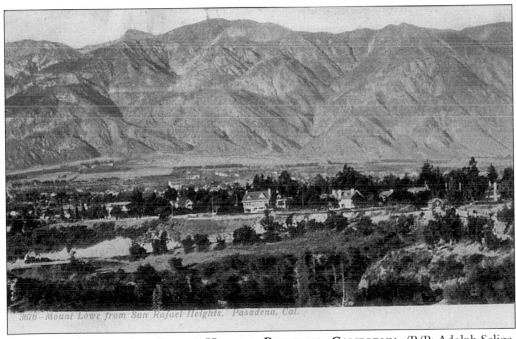

MOUNT LOWE FROM SAN RAMON HEIGHTS, PASADENA, CALIFORNIA. (P/P: Adolph Selige. St. Louis, Leipzig, Berlin. No. 3676. Printed in Germany.)

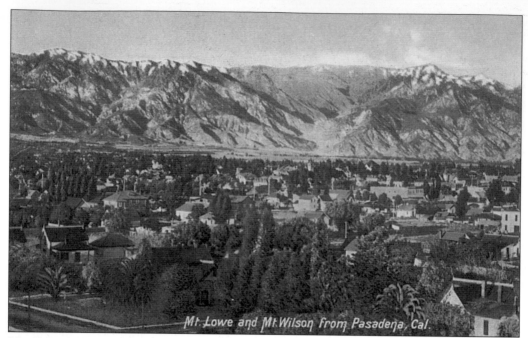

MT. LOWE AND MT. WILSON FROM PASADENA, CALIFORNIA. (P/P: Newman Post Card Co., Los Angeles. No. C27. Made in Germany.)

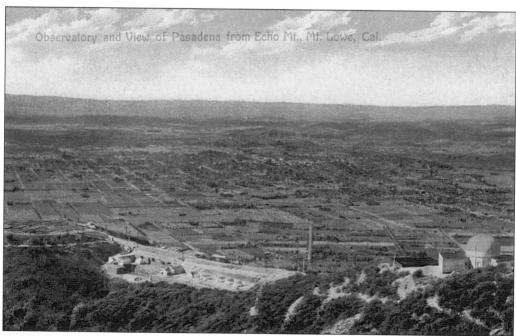

OBSERVATORY AND VIEW OF PASADENA FROM ECHO MT., MT. LOWE, CALIFORNIA. (P/P: Newman Post Card Co., Los Angeles. No. C14. Made in Germany.)

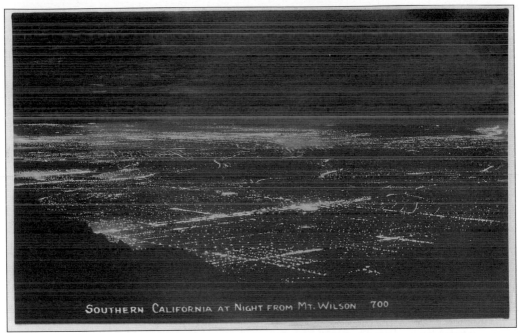

SOUTHERN CALIFORNIA AT NIGHT FROM MT. WILSON. (P/P: Unknown. No. 700.)

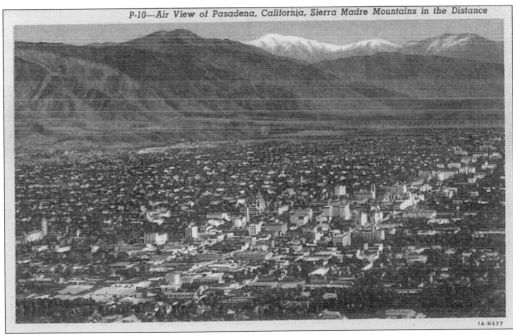

AIR VIEW OF PASADENA, CALIFORNIA, SIERRA MADRE MOUNTAINS IN THE DISTANCE. (P/P: Western Publishing & Novelty Co., Los Angeles. No. P10.)

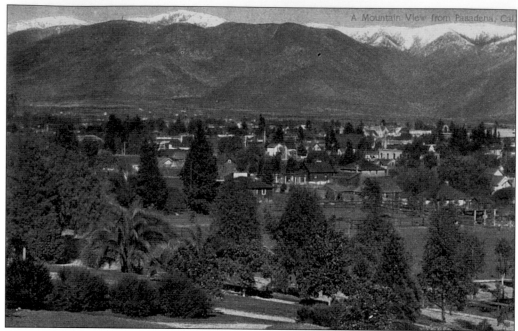

A Mountain View from Pasadena, California. (P/P: Newman Post Card Co., Los Angeles. No. B1. Made in Germany.)

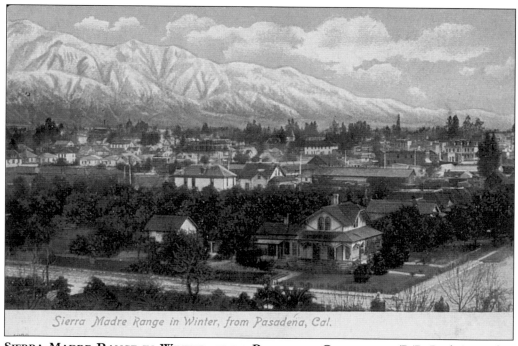

Sierra Madre Range in Winter, from Pasadena, California. (P/P: Paul C. Koeber Co., New York & Kirchheim [Germany]. No. 4278.)

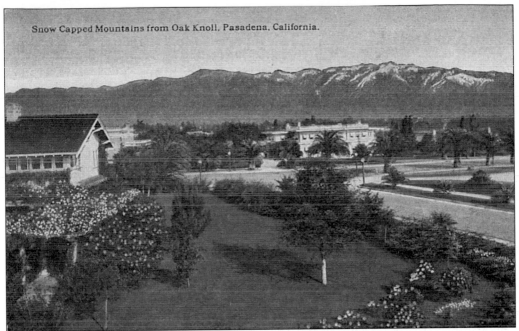

Snow Capped Mountains from Oak Knoll, Pasadena, California.

SNOW-CAPPED MOUNTAINS FROM OAK KNOLL, PASADENA, CALIFORNIA. (P/P: Western Publishing & Novelty Co., Los Angeles. No. R82505.)

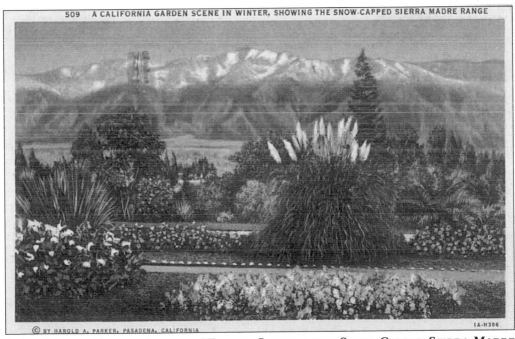

509 A CALIFORNIA GARDEN SCENE IN WINTER, SHOWING THE SNOW-CAPPED SIERRA MADRE RANGE

© BY HAROLD A. PARKER, PASADENA, CALIFORNIA 1A-H386

A CALIFORNIA GARDEN SCENE IN WINTER, SHOWING THE SNOW-CAPPED SIERRA MADRE RANGE. (P/P: Western Publishing & Novelty Co., No. 509. Postmark: February 1944.)

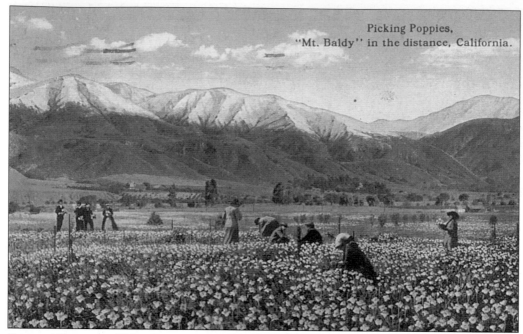

PICKING POPPIES, "MT. BALDY" IN THE DISTANCE, CALIFORNIA. Text on this card reads: "An interesting and beautiful sight, when the poppies are in bloom. Acres and acres will be a mass of this golden yellow. The Poppy is the State Flower of California, and is a different variety from that which they get opium." (P/P: Western Publishing & Novelty Co., Los Angeles. No. 508. Postmark: December 1921.)

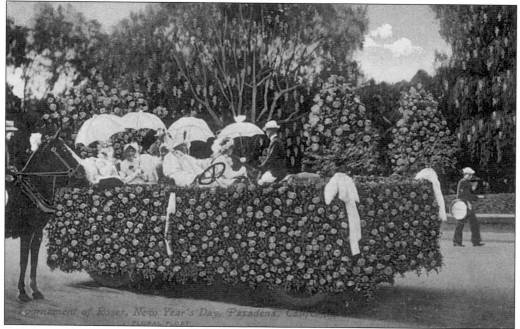

FLORAL FLOAT IN THE TOURNAMENT OF ROSES, NEW YEAR'S DAY, PASADENA, CALIFORNIA. (P/P: Souvenir Publishing Co., San Francisco. Postmark: November 1918.)

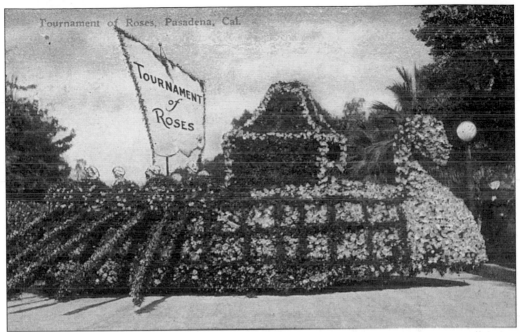

TOURNAMENT OF ROSES, PASADENA, CALIFORNIA. Text on this card states. "Every New Year's Day. Floral Pageant of Flowers." (P/P: Geo. Rice & Sons Printers, Los Angeles. Postmark: December 1913.)

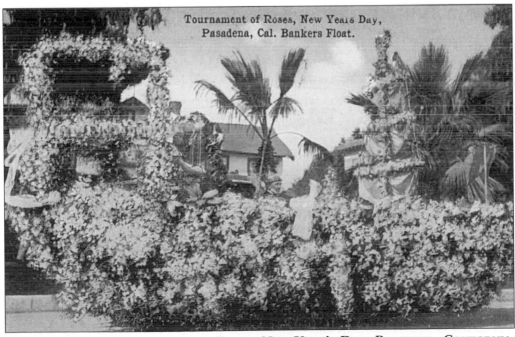

BANKERS FLOAT, TOURNAMENT OF ROSES, NEW YEAR'S DAY, PASADENA, CALIFORNIA. (P/P: Western Publishing & Novelty Co., Los Angeles.)

PASADENA'S TOURNAMENT OF ROSES ON NEW YEAR'S DAY. (P/P: Newman Post Card Co., Los Angeles. No. B115. Made in Germany.)

TOURNAMENT OF ROSES, NEW YEAR'S DAY, PASADENA, CALIFORNIA. (P/P: M. Rieder, Los Angeles. No. F46.)

FLORAL FLOAT IN THE TOURNAMENT OF ROSES, NEW YEAR'S DAY, PASADENA, CALIFORNIA. (P/P: Souvenir Publishing Co., San Francisco.)

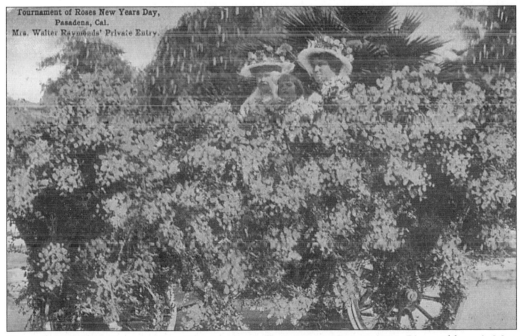

TOURNAMENT OF ROSES, NEW YEAR'S DAY, PASADENA, CALIFORNIA. Pictured here is Mrs. Walter Raymond's private entry. (P/P: Western Publishing & Novelty Co., Los Angeles.)

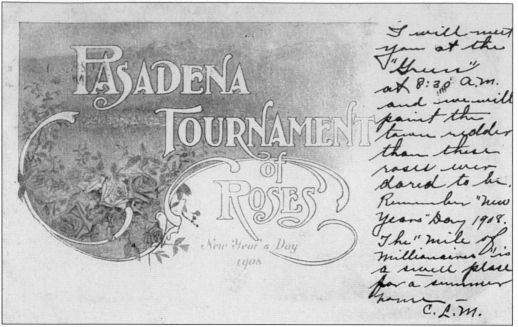

PASADENA TOURNAMENT OF ROSES, NEW YEAR'S DAY, 1908. The message on this card states: "I will meet you on the 'Green' at 8:30 am and we will paint the town redder than these roses ever dared to be. Remember "New Year's Day 1908. The 'Mile of Millionaires' is a swell place for a summer home." (P/P: Unknown. Undivided back. Postmark: July 1907.)

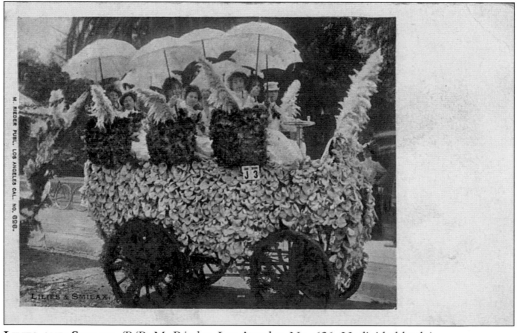

LILIES AND SMILAX. (P/P: M. Rieder, Los Angeles. No. 626. Undivided back.)

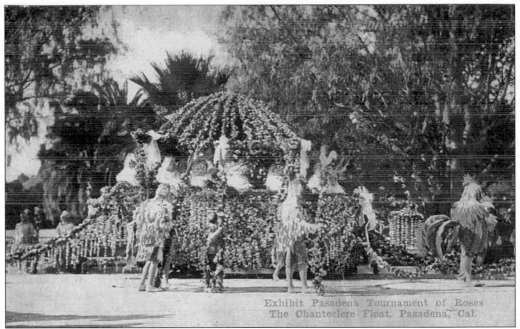

EXHIBIT PASADENA TOURNAMENT OF ROSES, THE CHANTECLERE FLOAT (P/P: O. Newman Co., Los Angeles & San Francisco. Postmark: December 1911.)

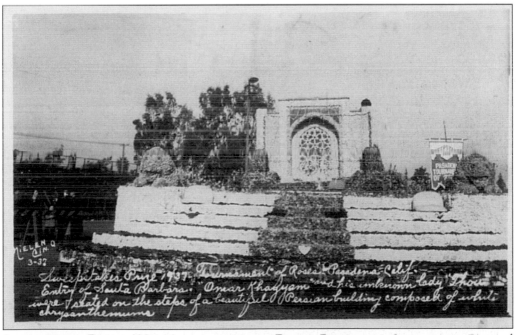

SWEEPSTAKES PRIZE 1937 TOURNAMENT OF ROSES PASADENA, CALIFORNIA. Pictured above is an entry of Santa Barbara. Omar Khayam and his unknown lady "Thou" were seated on the steps of a beautiful Persian building composed of white chrysanthemums. (P/P: Nielen Cin. Q 3–37. Postmark: January 1907.)

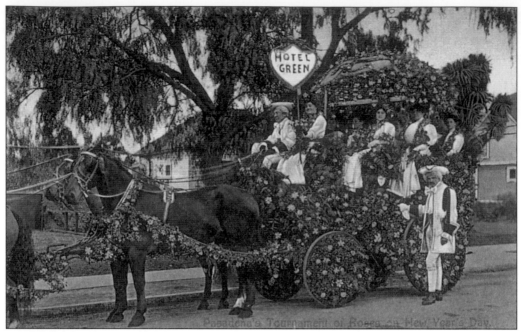

PASADENA'S TOURNAMENT OF ROSES ON NEW YEAR'S DAY. (P/P: Newman Post Card Co., Los Angeles. No. B112. Made in Germany.)

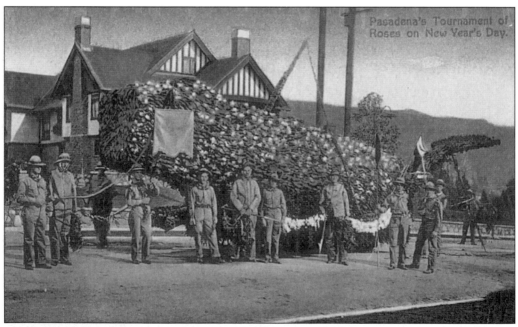

PASADENA'S TOURNAMENT OF ROSES ON NEW YEAR'S DAY. The message on this card reads: "This is to represent a whale but it does not show very plainly in the picture." (P/P: Newman Post Card Co., Los Angeles. No. B117. Made in Germany.)

Six

PASADENA'S MOUNTAINS

MT. WILSON AND MT. LOWE

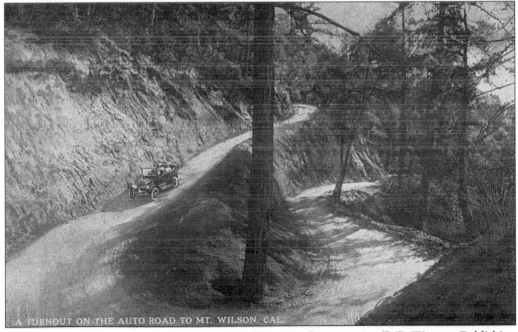

A TURNOUT ON THE AUTO ROAD TO MT. WILSON, CALIFORNIA. (P/P: Western Publishing & Novelty Co., Los Angeles. No. 754.)

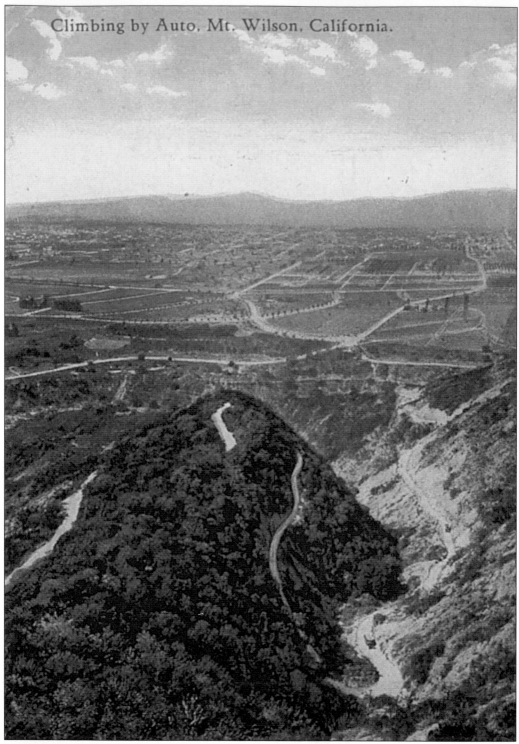

CLIMBING BY AUTO, MT. WILSON, CALIFORNIA. (P/P: Western Publishing & Novelty Co., No. P26.)

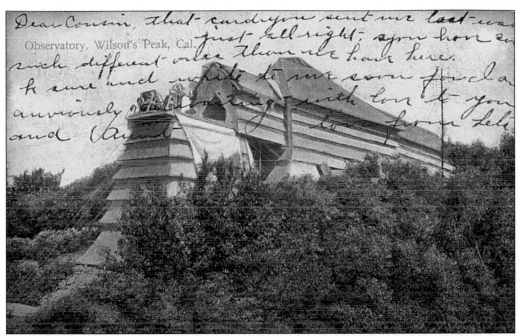

Observatory, Wilson's Peak, Cal.

Dear Cousin, that card you sent me last week just all right; you have so such different ones than we have here. Be sure and write to me soon for I am anxiously waiting with love to you and (Aunt) from Lele

OBSERVATORY, MT. WILSON'S PEAK, CALIFORNIA. (P/P: M. Rieder, Los Angeles & Leipzig, No. 3630. Postmark: October 1907.)

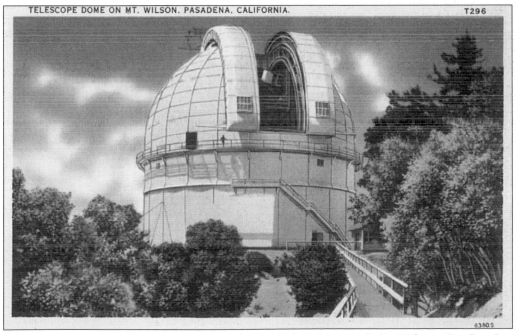

TELESCOPE DOME ON MT. WILSON, PASADENA, CALIFORNIA. T296

63805

TELESCOPE DOME ON MT. WILSON, PASADENA, CALIFORNIA. (P/P: Tichnor Art Co., Los Angeles. No. T296.)

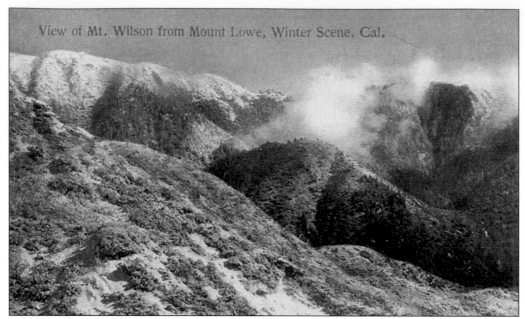

VIEW OF MT. WILSON FROM MT. LOWE, WINTER SCENE, CALIFORNIA. (P/P: M. Rieder, Los Angeles. No. 4604. Made in Germany. Handwritten date: November 1908.)

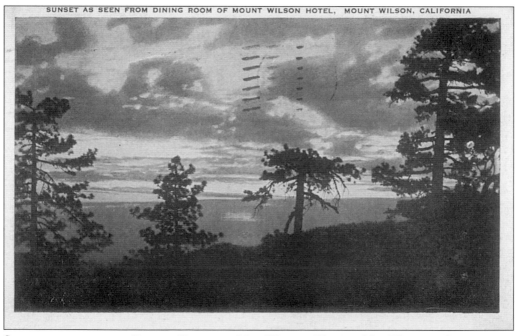

SUNSET AS SEEN FROM DINING ROOM OF MT. WILSON HOTEL, MT. WILSON, CALIFORNIA. (P/P: E.C. Kropp, Milwaukee. No. 7631–N. Postmark: April 1930.)

SAN ANTONIO "OLD BALDY" FROM ECHO ROCK, MT. WILSON, CALIFORNIA. (P/P: M. Rieder, Los Angeles. No. 5350. Made in Germany.)

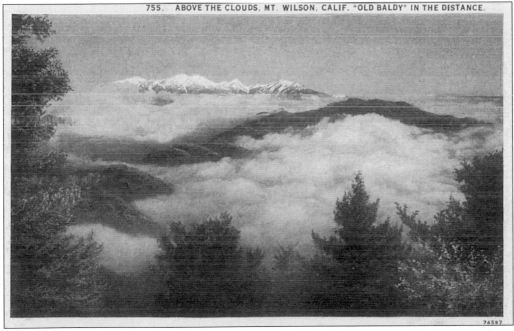

ABOVE THE CLOUDS, MT. WILSON, CALIFORNIA. "Old Baldy" is in the distance. (P/P: Western Publishing & Novelty Co., Los Angeles. No. 755.)

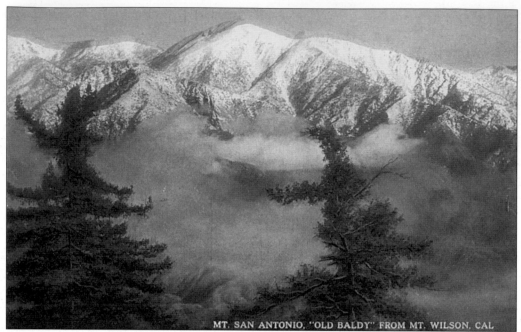

MT. SAN ANTONIO "OLD BALDY" FROM MT. WILSON, CALIFORNIA. (P/P: Western Publication & Novelty Co., Los Angeles. No. 751.)

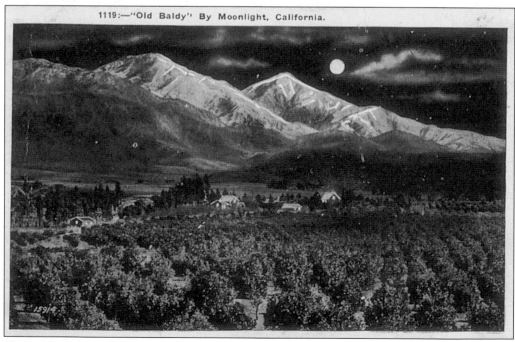

"OLD BALDY" BY MOONLIGHT, CALIFORNIA. Orange groves are pictured in the foreground. (P/P: M. Kashower, Los Angeles. No. 1119. Postmark: October 1924.)

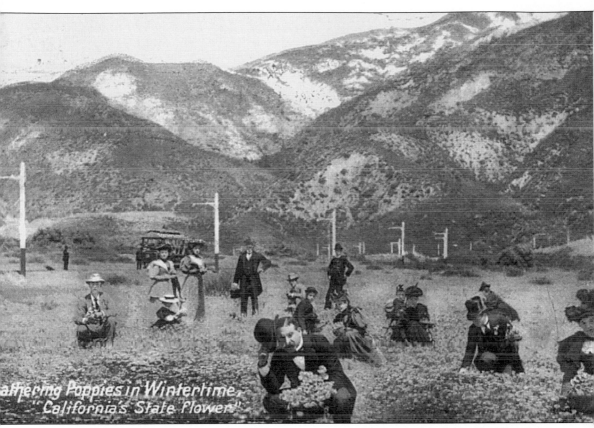

GATHERING POPPIES, CALIFORNIA'S STATE FLOWER, IN WINTERTIME. A Pacific Electric train car and standards are visible in the background en route to Mt. Lowe. (P/P: Newman Post Card Co., Los Angeles. No. B12. Made in Germany. Postmark: March 1909.)

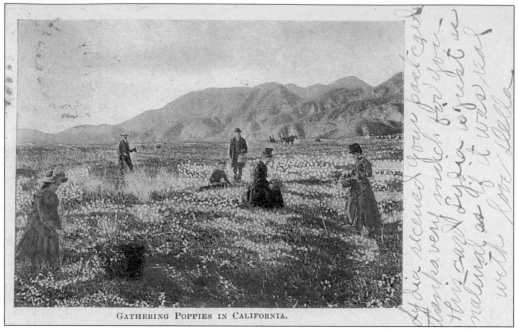

GATHERING POPPIES IN CALIFORNIA.

GATHERING POPPIES IN CALIFORNIA. (P/P: M. Rieder, Los Angeles. No. 193. Undivided back. Postmark: July 1907.)

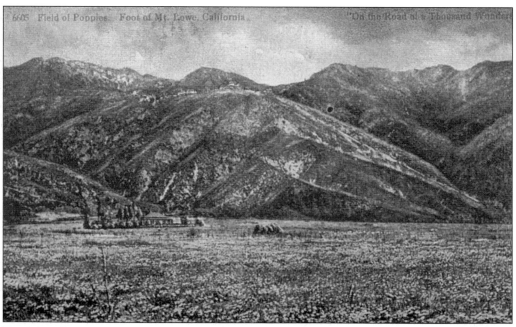

6605 Field of Poppies. Foot of Mt. Lowe, California. "On the Road of a Thousand Wonders"

FIELD OF POPPIES AT THE FOOT OF MT. LOWE. (P/P: Edward H. Mitchell, San Francisco. No. 6605.)

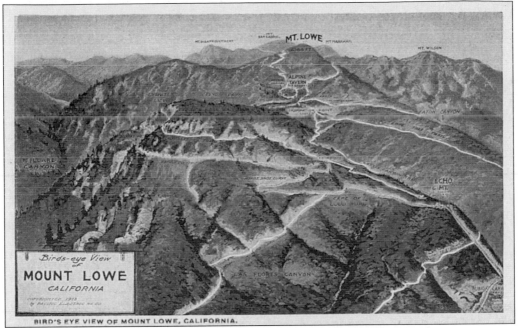

BIRD'S EYE VIEW OF MOUNT LOWE, CALIFORNIA.

BIRD'S-EYE VIEW OF MOUNT LOWE, CALIFORNIA. The Pacific Electric track is visible in the lower right corner through Rubio Canyon, then up the incline to Echo Mountain. From there, the track went left past Cape of Good Horn to the Horse Shoe Curve and up to the Circular Bridge—from the bridge left to Granite Gate and around the mountain to Inspiration Point and the final destination, Alpine Tavern.(P/P: C.T. American Art. No. R62954. Copyrighted 1913, Pacific Electric Railway.)

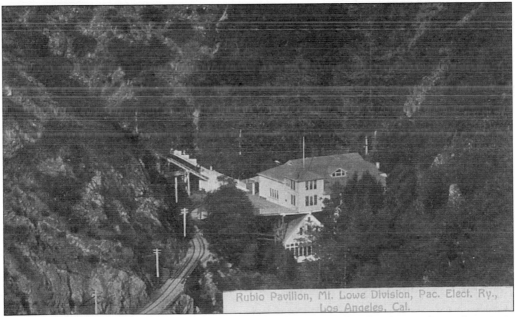

Rubio Pavilion, Mt. Lowe Division, Pac. Elect. Ry., Los Angeles, Cal.

RUBIO PAVILION, MT. LOWE DIVISION, PACIFIC ELECTRIC RAILWAY, LOS ANGELES, CALIFORNIA. (P/P: Newman Post Card Co., Los Angeles. No. C6. Made in Germany.)

101

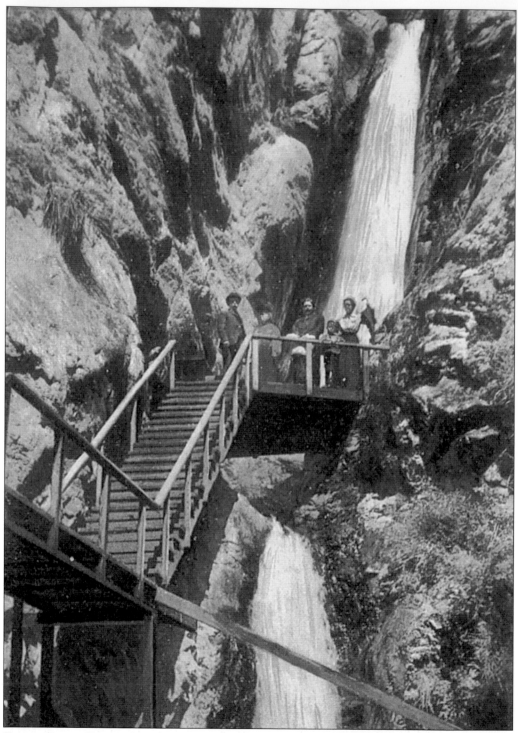

RUBIO ROCK FALLS, RUBIO CANYON, MT. LOWE, CALIFORNIA. Text on the card reads: "This beautiful canyon is at the base of Mt. Lowe and is visited by many beauty lovers, and picnic parties." (P/P: M. Rieder, Los Angeles. No. 4651. Made in Germany.)

MOUNT LOWE INCLINE, PASADENA, CALIFORNIA. (P/P: Acmegraph Co., Chicago. No. 11495. Postmark: January 1917.)

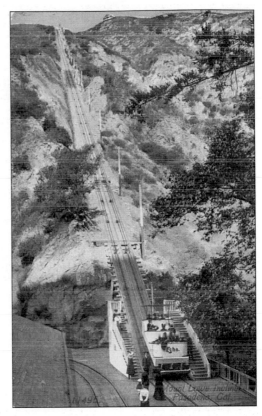

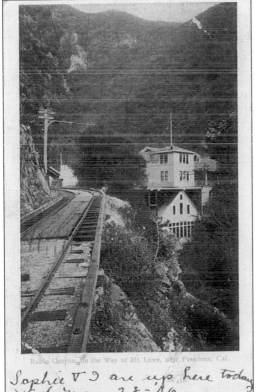

RUBIO CANYON, ON THE WAY TO MT. LOWE, NEAR PASADENA, CALIFORNIA. (P/P: M. Rieder, Los Angeles & Leipzig. No. 3232. Undivided back. Postmark: March 1906.)

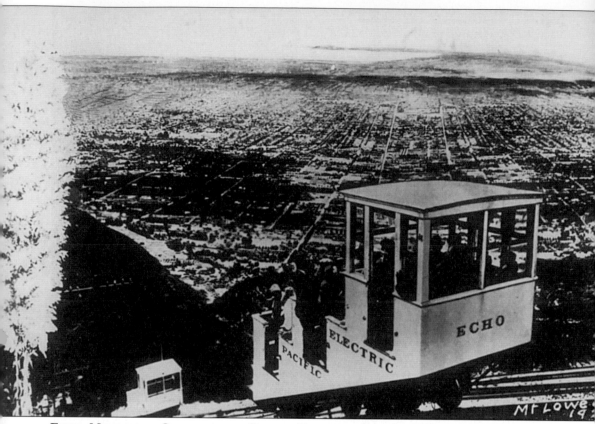

ECHO MOUNTAIN CARD OF THE PACIFIC ELECTRIC INCLINE RAILWAY ON MT. LOWE, CALIFORNIA. (P/P: Unknown. Photo dated: 1921.)

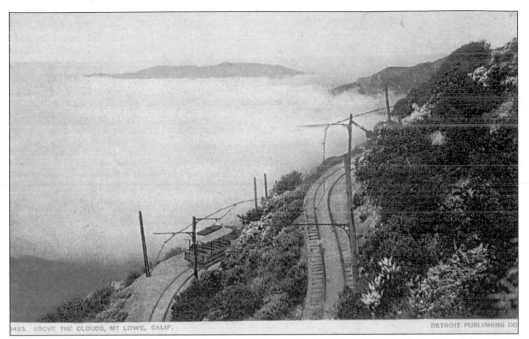

ABOVE THE CLOUDS, MT. LOWE, CALIFORNIA. (P/P; Detroit Publishing Co., No. 9423. Printed in Switzerland.)

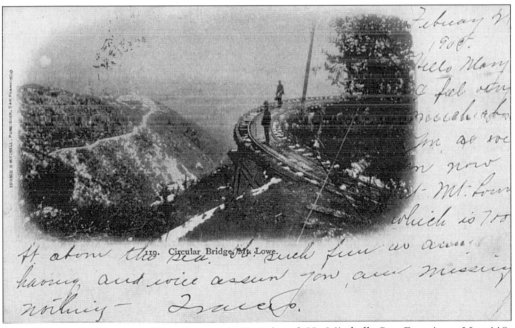

THE CIRCULAR BRIDGE, MT. LOWE. (P/P: Edward H. Mitchell, San Francisco. No. 119. Undivided back. Postmark: February 1905.)

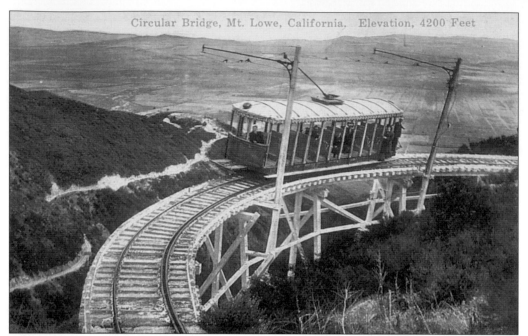

CIRCULAR BRIDGE, MT. LOWE, CALIFORNIA. The elevation of this bridge was 4,200 feet. (P/P: Pacific Novelty Co., San Francisco. No. H5.)

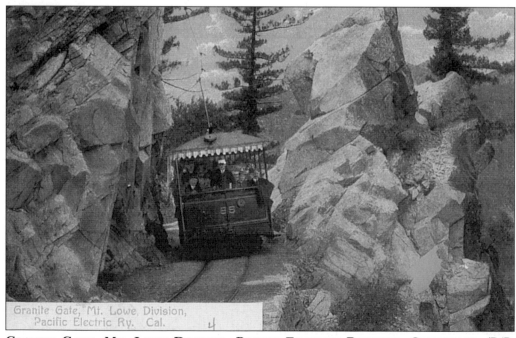

GRANITE GATE, MT. LOWE DIVISION, PACIFIC ELECTRIC RAILWAY, CALIFORNIA. (P/P: Newman Post Card Co., Los Angeles. No. C11.)

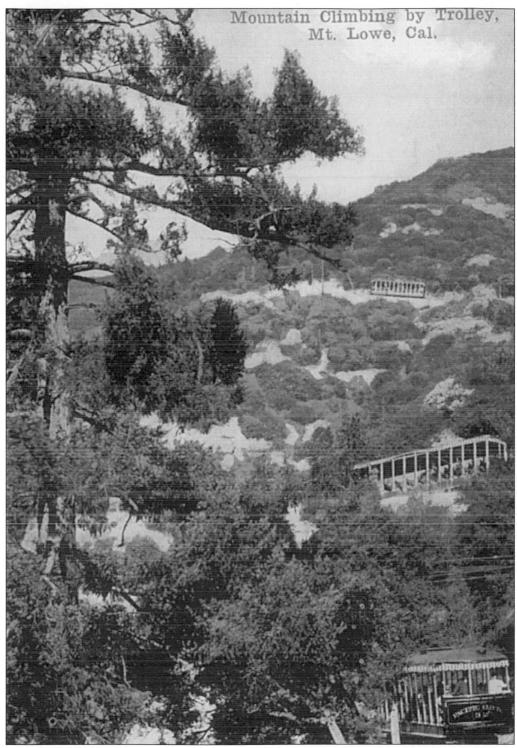

MOUNTAIN CLIMBING BY TROLLEY, MT. LOWE, CALIFORNIA. (P/P: Mt. Lowe Post Card, California.)

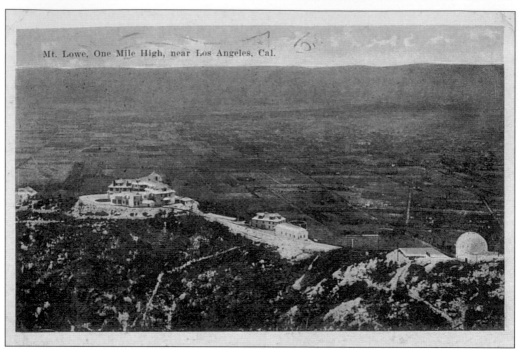

MT. LOWE, ONE MILE HIGH, NEAR LOS ANGELES, CALIFORNIA. (P/P: Unknown. No. 23872N. Postmark: November 1921.)

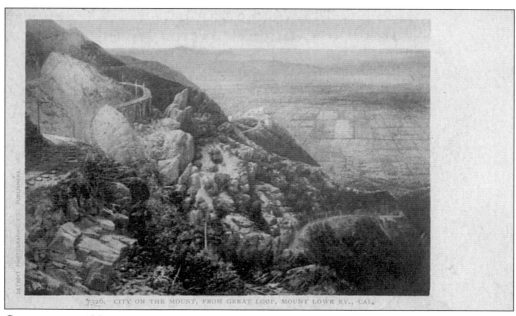

CITY ON THE MOUNT, FROM GREAT LOOP, MT. LOWE RAILWAY, CALIFORNIA. (P/P: Detroit Photographic Co. No. 7326. Undivided back.)

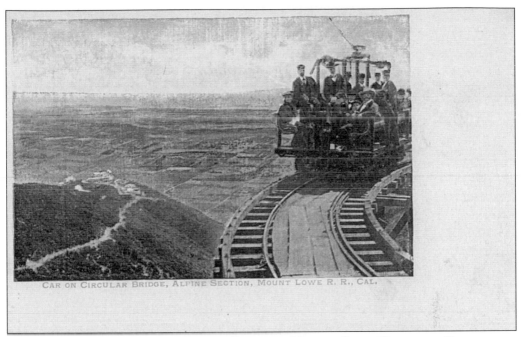

CAR ON CIRCULAR BRIDGE, ALPINE SECTION, MOUNT LOWE RAILWAY, CALIFORNIA. (P/P: M. Rieder, Los Angeles. No. 523. Undivided back.)

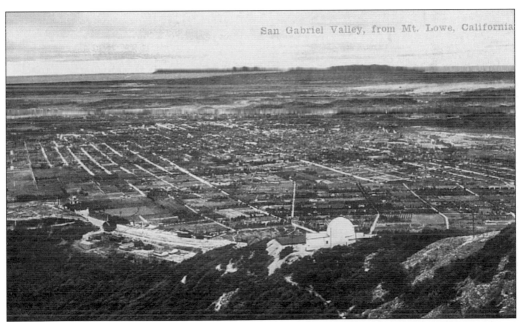

SAN GABRIEL VALLEY FROM MT. LOWE, CALIFORNIA. (P/P: Van Ornum Colorprint, Los Angeles. No. 561.)

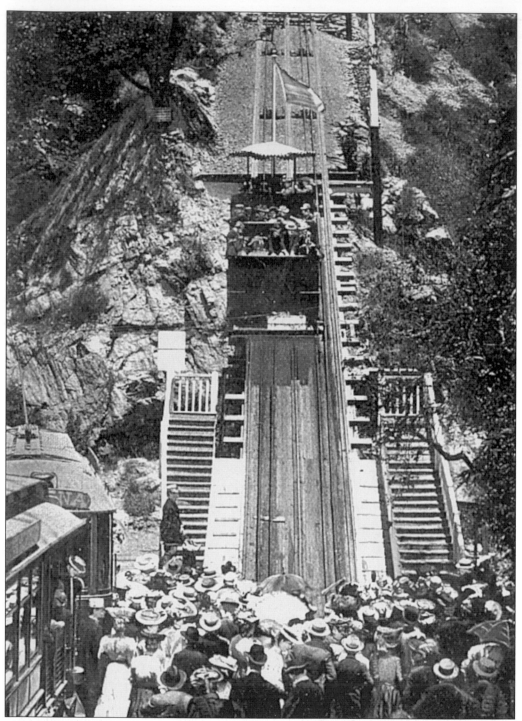

MT. LOWE INCLINE, NEAR PASADENA, CALIFORNIA. This is a double card. Passengers are transferring from the regular Pacific Electric cars, to the left, to the Incline car. At the top of the Incline (Echo Mountain), they will change again to the cars of the Alpine Division of the P.E. for travel on to the Alpine Tavern. (P/P: M. Rieder, Los Angeles. No. 3480. Made in Germany.)

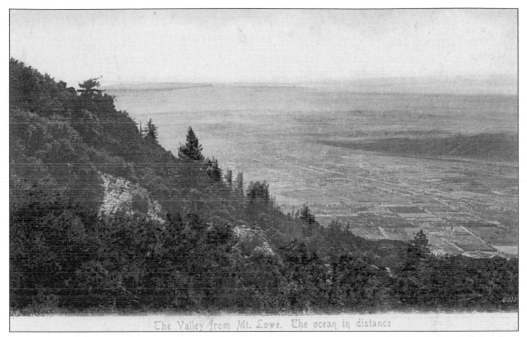

THE VALLEY FROM MT. LOWE WITH THE OCEAN IN THE DISTANCE. (P/P: M. Rieder, Los Angeles & Dresden. No. 9000.)

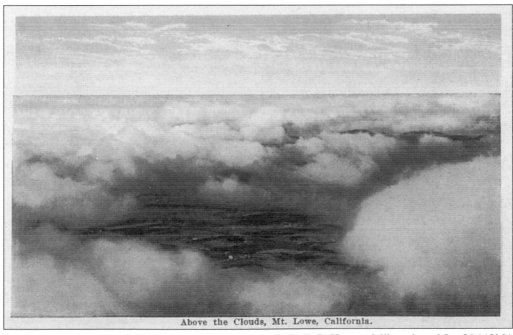

ABOVE THE CLOUDS, MT. LOWE, CALIFORNIA. (P/P: E.C. Kropp, Milwaukee. No. 28642N.)

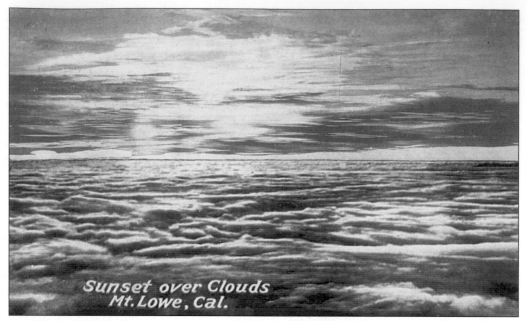

SUNSET OVER CLOUDS, MT. LOWE, CALIFORNIA. (P/P: Pacific Novelty Co., San Francisco & Los Angeles. No. H11.)

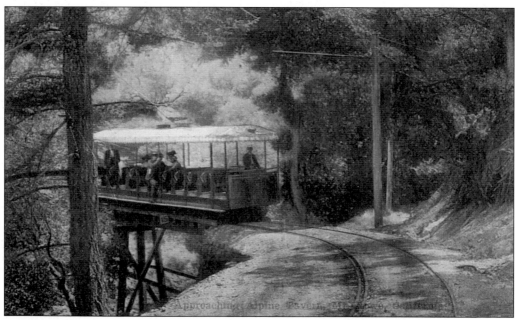

APPROACHING ALPINE TAVERN, MT. LOWE, CALIFORNIA. (P/P: Newman Post Card Co., Los Angeles. No. C22. Postmark: August 1911.)

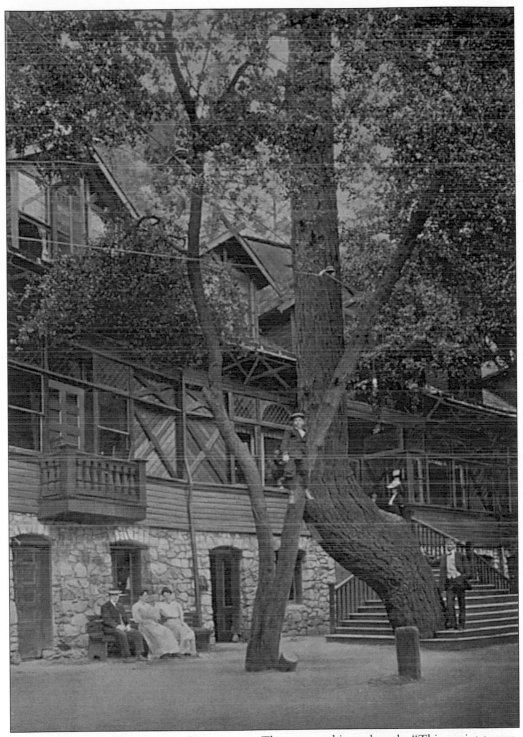

ALPINE TAVERN, MT. LOWE, CALIFORNIA. The text on this card reads: "This quaint tavern, much resembling a Swiss Chalet, is the terminus of the Mt. Lowe trip and much appreciated by lovers of mountain resorts." (P/P: M. Rieder, Los Angeles. No. 4652. Made in Germany.)

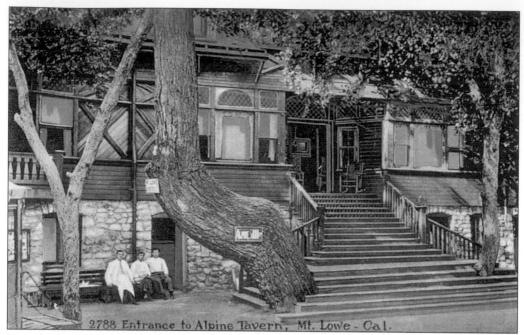

ENTRANCE TO ALPINE TAVERN, MT. LOWE, CALIFORNIA. (P/P: Edward H. Mitchell, San Francisco. No. 2788. Postmark: July 1911.)

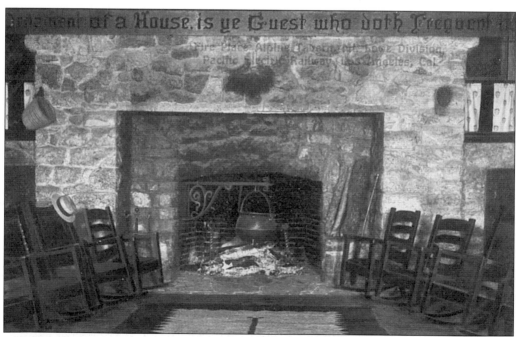

FIRE PLACE ALPINE TAVERN, MT. LOWE DIVISION PACIFIC ELECTRIC RAILWAY, LOS ANGELES, CALIFORNIA. (P/P: Newman Post Card Co., Los Angeles. No. C7. Made in Germany.)

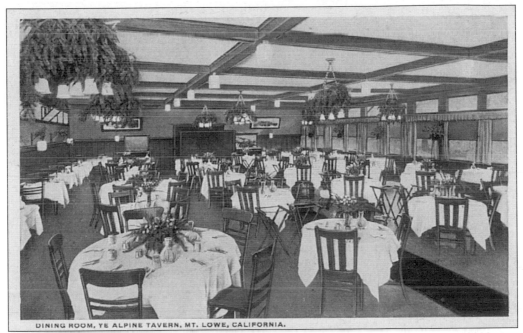

DINING ROOM OF YE ALPINE TAVERN, MT. LOWE, CALIFORNIA. (P/P: C.T. American Art. No. 62966.)

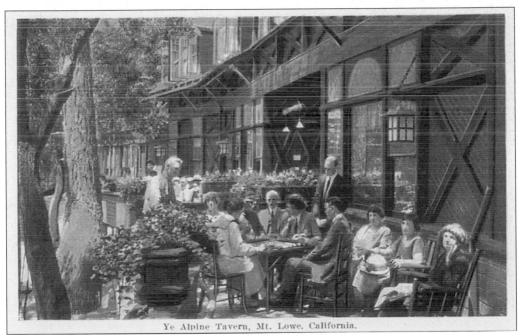

YE ALPINE TAVERN IN MT. LOWE, CALIFORNIA. (P/P: E.C. Kropp, Milwaukee. No. 28651N.)

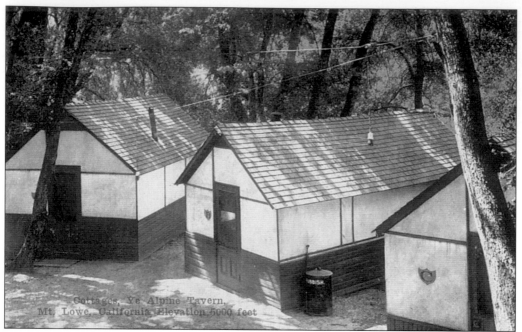

COTTAGES AT YE ALPINE TAVERN, MT. LOWE, CALIFORNIA/ELEVATION: 5,000 FEET. (P/P: Mt. Lowe Post Card.)

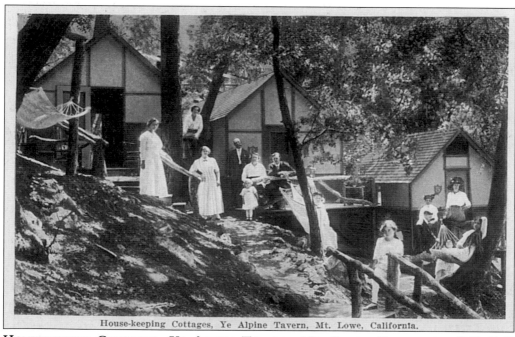

HOUSEKEEPING COTTAGES, YE ALPINE TAVERN, MT. LOWE, CALIFORNIA. (P/P: E.C. Kropp, Milwaukee. No. 28653N.)

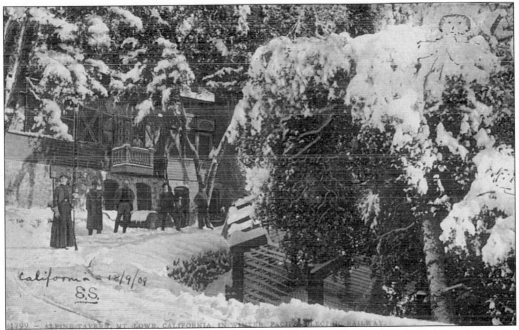

ALPINE TAVERN IN MT. LOWE, CALIFORNIA, IN WINTER. The Pacific Electric Railway is also pictured. (P/P: Edward H. Mitchell, San Francisco. No. 1799. Postmark: September 1909.)

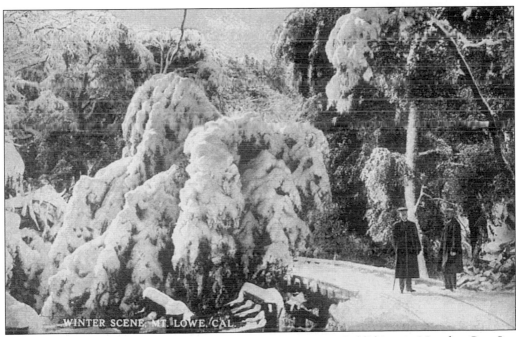

WINTER SCENE, MT. LOWE, CALIFORNIA. (P/P: Western Publishing & Novelty Co., Los Angeles. No. 705.)

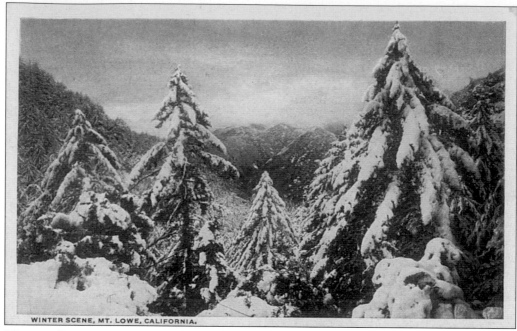

WINTER SCENE, MT. LOWE, CALIFORNIA. (P/P: C.T. American Art. No. R62953.)

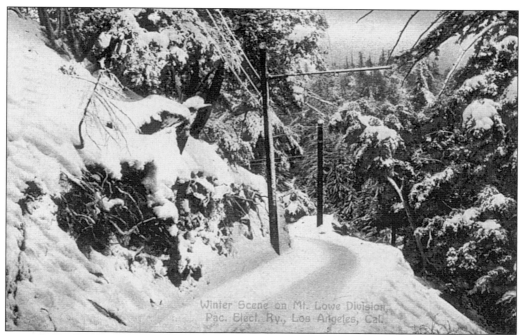

WINTER SCENE ON THE MT. LOWE DIVISION, PACIFIC ELECTRIC RAILWAY, LOS ANGELES, CALIFORNIA. (P/P: Newman Post Card Co., Los Angeles. No. C5. Made in Germany. Postmark: September 1909.)

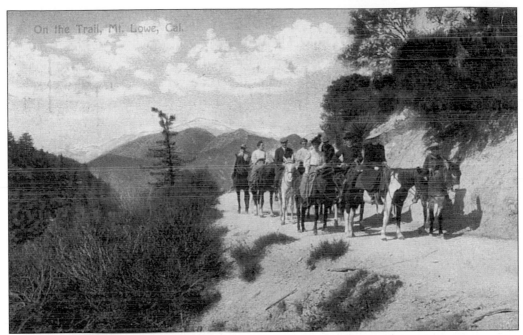

ON THE TRAIL, MT. LOWE, CALIFORNIA. (P/P: Newman Post Card Co., Los Angeles. No. C4. Made in Germany. Postmark: July 1909.)

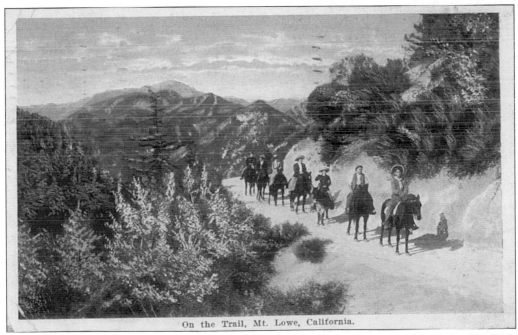

On the Trail, Mt. Lowe, California.

ON THE TRAIL, MT. LOWE, CALIFORNIA. (P/P: E.C. Kropp, Milwaukee. No. 28657N. Postmark: December 1926.)

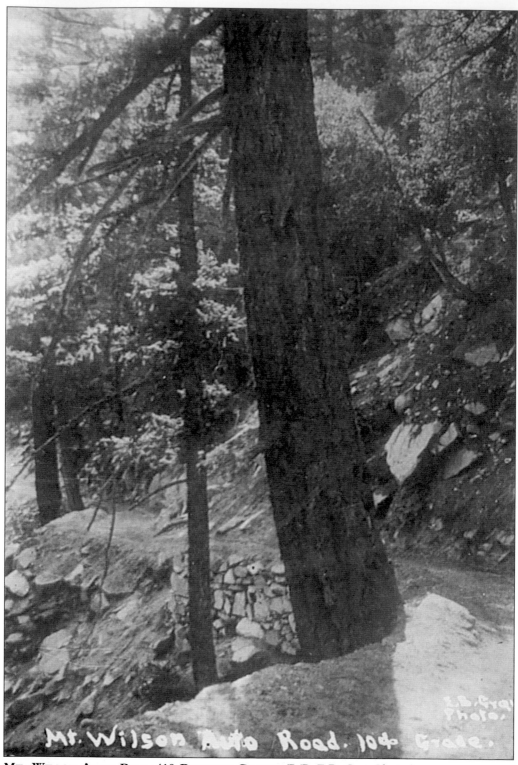

MT. WILSON AUTO ROAD/10 PERCENT GRADE. (P/P: E.B. Gray Photo.)

Seven

NEARBY SIGHTS

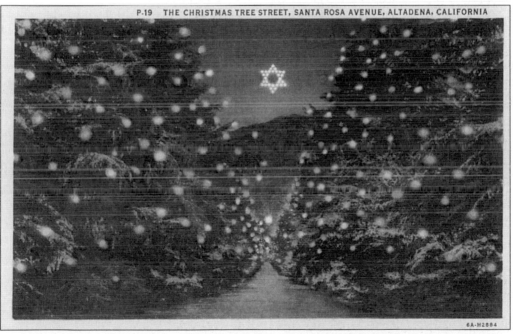

P-19 THE CHRISTMAS TREE STREET, SANTA ROSA AVENUE, ALTADENA, CALIFORNIA

6A-H2884

THE CHRISTMAS TREE STREET, SANTA ROSA AVENUE, ALTADENA, CALIFORNIA. Text from this card states: "The trees are majestic Himalayan cedars grown from seed brought from the slopes of the Himalayan mountains in India, where the deodor is famed in song and story, its name signifying 'Tree of God.'. . . . There are about two hundred trees that were planted in 1885. . . . This was once the main driveway on the 900 acre ranch of Col. F.J. Woodbury, a pioneer resident. . . . The custom of lighting the trees was started in 1920. . . ." (P/P: Western Publishing & Novelty Co., Los Angeles. No. P19.)

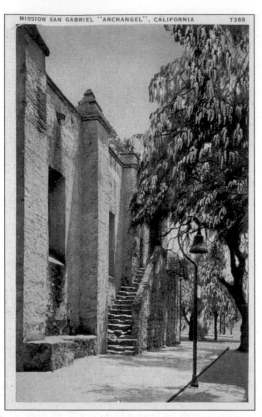

MISSION SAN GABRIEL "ARCHANGEL," CALIFORNIA. This was the fourth mission in California, founded September 8, 1771, by the Franciscan fathers. (P/P: Tichnor Art Co., Los Angeles. No. T388.)

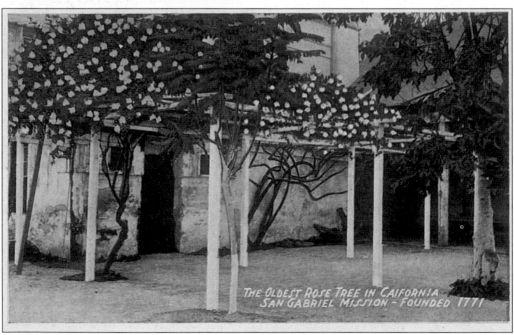

THE OLDEST RARE TREE IN CALIFORNIA, SAN GABRIEL MISSION—FOUNDED 1771. (P/P: Pacific Novelty Co., San Francisco & Los Angeles. No. Z69.)

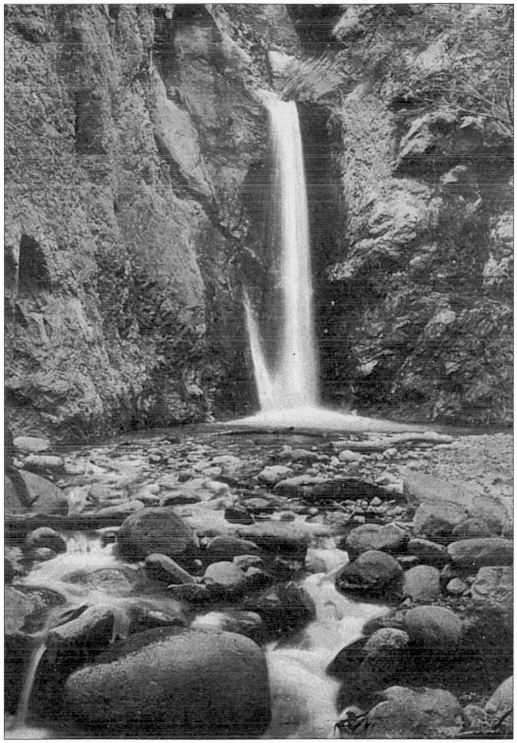

EATON'S FALLS, NEAR PASADENA, CALIFORNIA. (P/P: M. Rieder, Los Angeles. No. 3788. Made in Germany.)

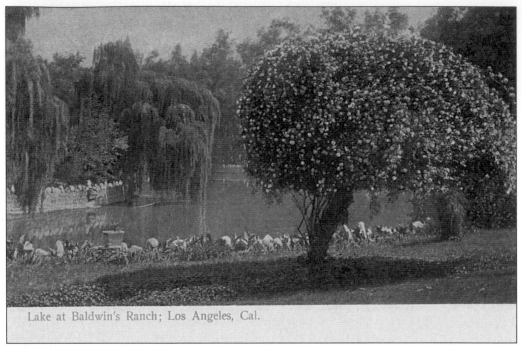

Lake at Baldwin's Ranch; Los Angeles, Cal.

LAKE AT BALDWIN'S RANCH, LOS ANGELES. (P/P: M. Rieder, Los Angeles. No. 3500. Made in Germany.)

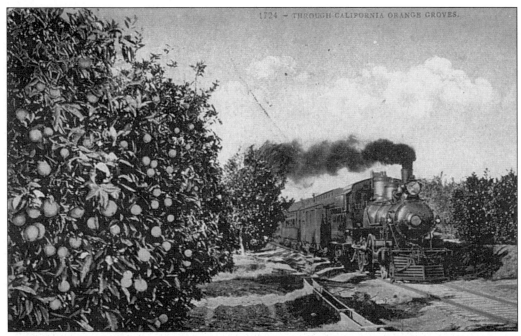

1724 - THROUGH CALIFORNIA ORANGE GROVES.

THROUGH THE CALIFORNIA ORANGE GROVES. The Santa Fe Railroad came through the groves of eastern Los Angeles County, stopping in Pasadena before its final stop in Los Angeles. (P/P: Edward H. Mitchell, San Francisco. No. 1724. Postmark: June 1910.)

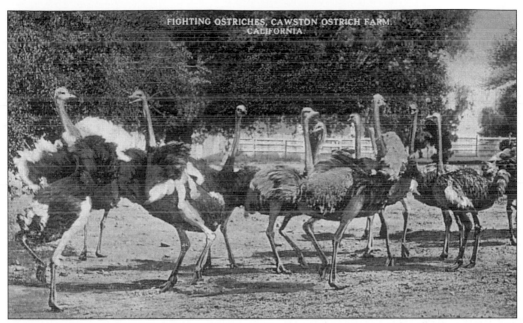

Fighting Ostriches, Cawston Ostrich Farm, California. Text on the card reads: "Surrounded by live oaks, orange trees and flowers, the Cawston Ostrich Farm at South Pasadena, California, furnishes one of the unique show places of the Pacific Coast." (P/P: C.T. Photochrome, Chicago. No. A61519.)

The Park, Cawston Ostrich Farm, South Pasadena, California. (P/P: Benham Indian Trading Co., Los Angeles. No. 1161.)

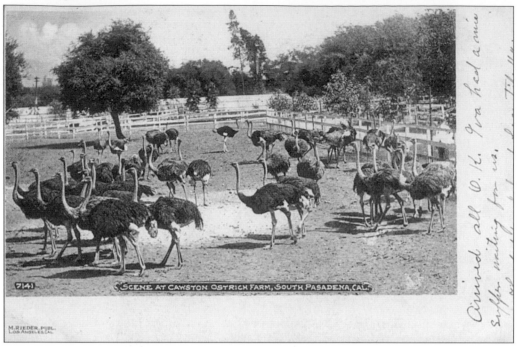

SCENE AT CAWSTONS OSTRICH FARM, SOUTH PASADENA, CALIFORNIA. (P/P: M. Rieder, Los Angeles. No. 7141. Undivided back. Postmark: August 1904.)

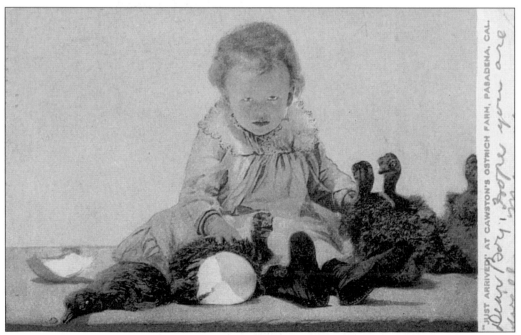

"JUST ARRIVED" AT CAWSTONS OSTRICH FARM, SOUTH PASADENA, CALIFORNIA. (P/P: E.P. Charlton & Co. Copyright 1898 by Graham. Undivided back. Postmark: August 1907.)

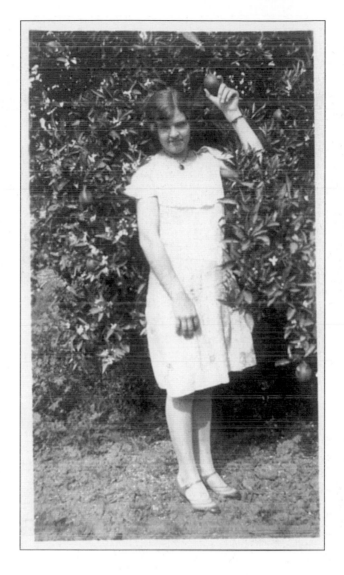

Dedicated to my Mother,

EVELYN EDMISTER HECKMAN,

in honor of her

Eighty-eighth birthday

February 25, 2001.

She became a Californian when her

family moved here from Iowa in 1926.

INDEX OF PUBLISHERS AND PHOTOGRAPHERS